MINEHEAD
& DUNSTER
THROUGH TIME
Simon Haines

AMBERLEY PUBLISHING

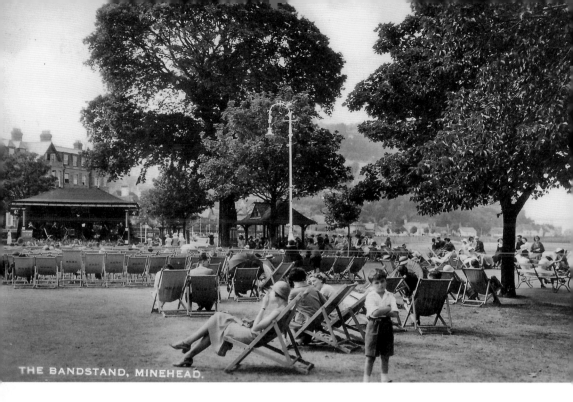

THE BANDSTAND, MINEHEAD.

The Bandstand, Minehead, *c.* 1925
Musicians entertaining the crowds at the bandstand on the promenade.

First published 2014

Amberley Publishing
The Hill, Stroud, Gloucestershire, GL5 4EP
www.amberley-books.com

Copyright © Simon Haines, 2014

The right of Simon Haines to be identified as the
Author of this work has been asserted in accordance with
the Copyrights, Designs and Patents Act 1988.

ISBN 978 1 4456 2176 0 (print)
ISBN 978 1 4456 2191 3 (ebook)

British Library Cataloguing in Publication Data.
A catalogue record for this book is available from the
British Library.

Typesetting by Amberley Publishing.
Printed in Great Britain.

Introduction

Almost 200 images in this book about Minehead and Dunster in West Somerset have been paired together to allow the reader to compare early twentieth-century views of the area with photographs of the same or similar location as it looks today. This has resulted, in most cases, in a gap of at least 100 years between the two pictures presented on each page.

In the years prior to the First World War, postcards were an extremely common and popular way of communicating with friends and family. Writing a postcard was by all accounts quite as usual then as it is to send an SMS text message or e-mail today. As a result, the majority of early images used in this work have been sourced from old picture postcards. These have been collected by the author over the last few years at antique markets, via individual online purchases, or by finding local images among larger mixed lots bought at auction. Thankfully, for the purposes of this work and research into local history generally, many thousands of picture postcards have survived the passing of years filed away in drawers and saved in albums throughout the world. Indeed, the postcards included here had been originally addressed and mailed to people as far afield as Germany and New Zealand. Other than the sourcing of historic images from old postcards, a smaller number of the archive pictures contained within the pages of this book have been obtained by reprinting from old glass negatives and original private photographs in the author's private collection.

The dating of original images can never be an exact science unless, as was the case in a handful of the images used, the specific date was recorded. Otherwise dates have been taken from postmarks recorded on the reverse of the postcards themselves, historical research into the material changes occurring in and around Minehead and Dunster, and through close examination of things like the clothing worn by people pictured or motor vehicles present. As a result, the majority of dates

cited are probably accurate to within plus or minus five years. The photographs of present-day Minehead and Dunster included were taken over several days between the months of July and December 2013.

The photographs in this pictorial tour of past and present Minehead and Dunster have been presented in an order that loosely approximates a walk around both locations. With Minehead our tour begins up on North Hill, comes down through Church Town, into the Harbour area, along the seafront, up through the town, and ends up in Alcombe. In the case of Dunster we start out at the Castle, wander along the High Street and into West Street and come to a rest not far from the watermill.

The author welcomes any and all correspondence on the subject of the local history of Minehead and Dunster. Comments, questions and requests for further information can be sent via the contact form on his website: www.haines.me.uk.

Minehead

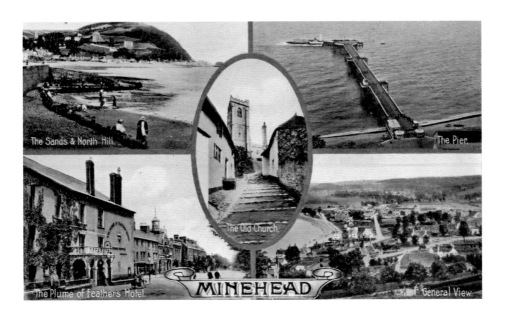

Minehead

We start our look at Minehead through time with a multi-view picture postcard mailed from the town's post office in 1913. This postcard features two landmarks, now long gone: the Pier and the Plume of Feathers Hotel. The photograph below is of a 'Thomas & Friends' event at the railway station organised by the West Somerset Railway, a successful heritage railway line, which has its terminus and headquarters in Minehead.

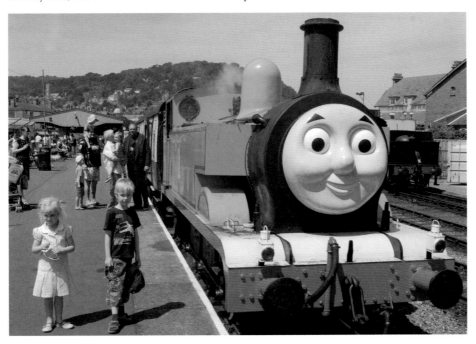

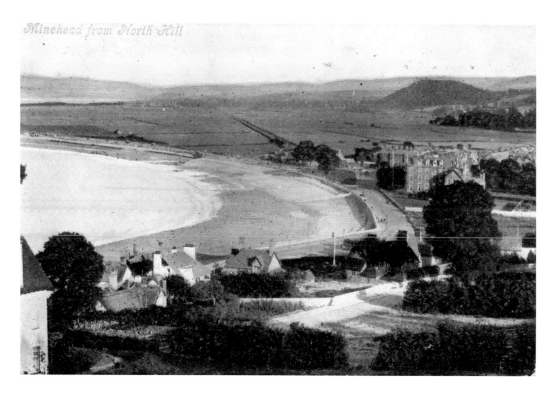

Minehead from North Hill, *c.* 1906
In this image of the town as seen from North Hill one can see how much it has grown over the years. The two parallel lines surrounded by fields are the railway line, opened just thirty years before, connecting Taunton with Minehead. The recent photograph is from a slightly different viewpoint focusing more on the area around the Church of St Michael.

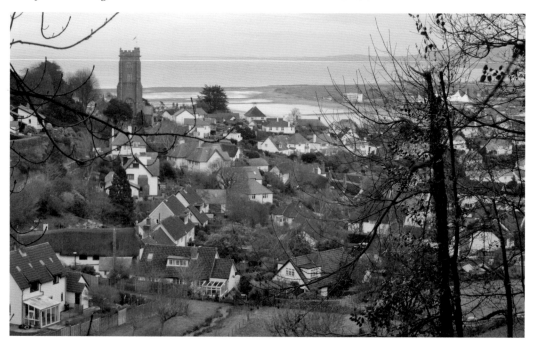

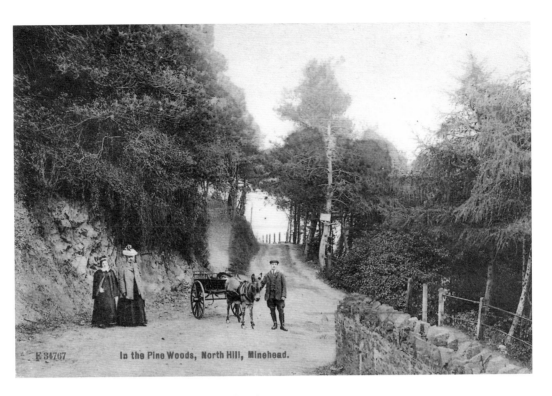

In the Pine Woods, North Hill, Minehead.

E 34767

In the Pine Woods, North Hill, Minehead, *c.* 1911

A donkey-drawn cart on the road up through the pine woods to the top of North Hill. This is a steep climb but, as it does today, would have provided visitors with marvellous views down across the Bristol Channel to the Welsh Coast and towards Dunster. The Land Rover is parked close to where the stone wall stood in the earlier photograph.

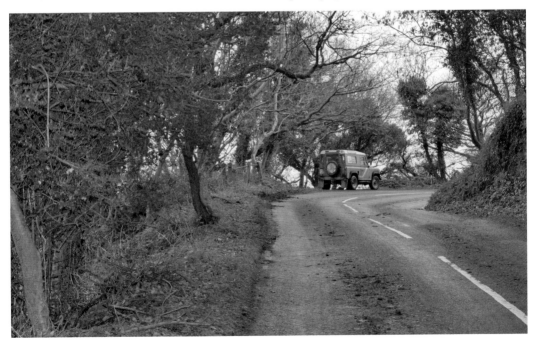

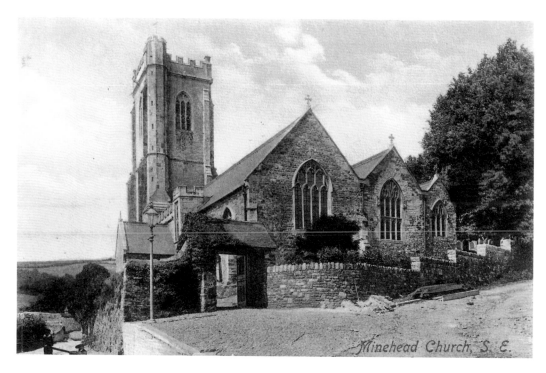

Church of St Michael, Minehead, c. 1905

Travelling down from North Hill we have the fifteenth-century church, which itself is visible from most of Minehead; so much so that its 87-foot-high tower used to display a beacon light for ships approaching the harbour. This part of the town is known rather imaginatively by locals as either Higher Town or Church Town.

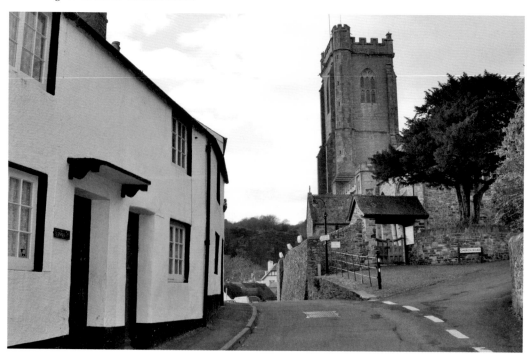

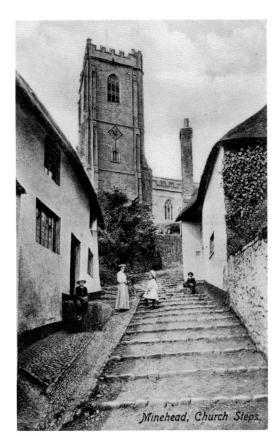

Church Steps, Minehead, c. 1905
The steps and thatched cottages leading up the church from the lower part of town look much as they did more than 100 years before.

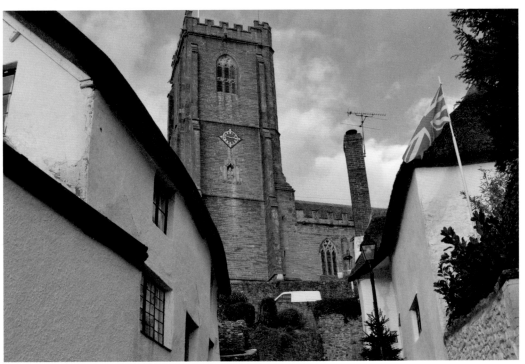

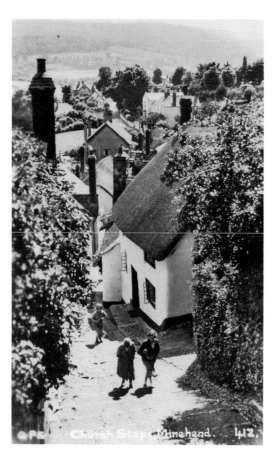

Church Steps, Minehead, *c.* 1935
In this photograph we see the same steps, looking down instead of up them. Note the vast development of the town visible in the photograph below.

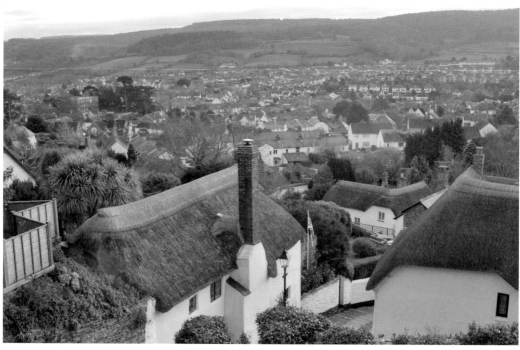

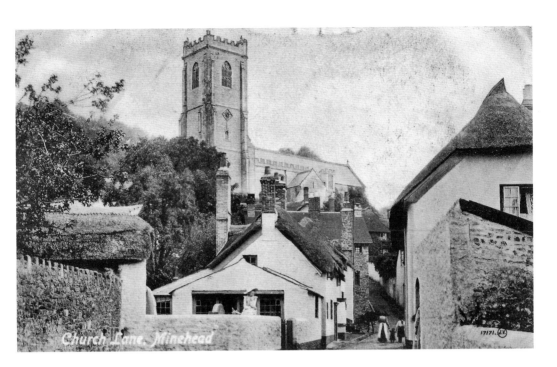

Church Lane, Minehead, *c.* 1904

Moving further down from the church and into Church Lane we have yet more picturesque thatched cottages. The cottages themselves have been enlarged over time and, from rather humble roots as workers' dwellings and a poorhouse, they have become very desirable properties. Many still feature the tall chimneys, which in many cases would have had a bread oven at their base. In the seventeenth century these chimneys were seen as something of a status symbol, with a taller chimney seen as a sign of wealth.

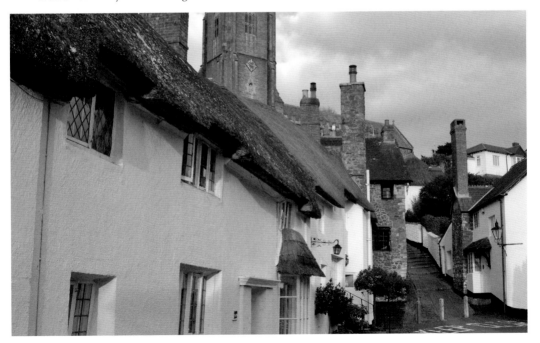

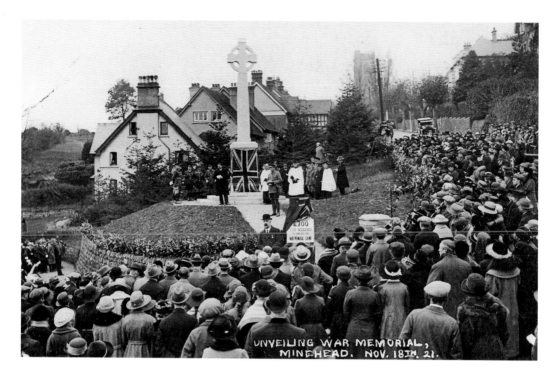

The War Memorial, Minehead, 1921

This photographic postcard features the unveiling of the town's war memorial on 18 November 1921. The monument bears the inscription 'In everlasting memory of the men of Minehead who laid down their lives in the Great War 1914–1918'. It lists the missing and dead of both the First World War (106 names) and Second World War (54 names).

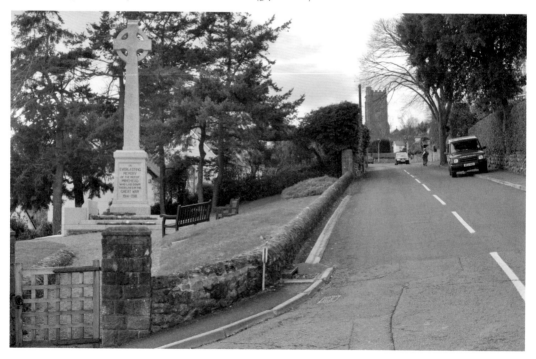

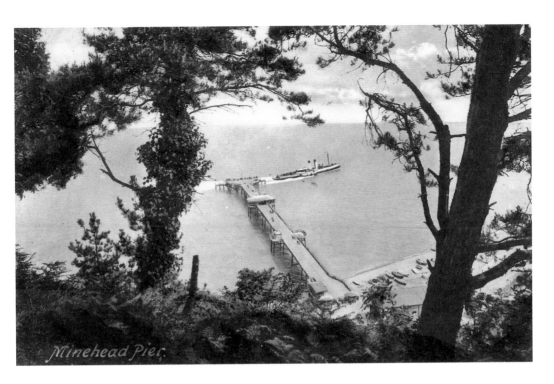

Minehead Pier, c. 1908

A picture postcard of the pier and a steamer soon after it was built in 1901. These steamships ferried the many day-trippers back and forth between the industrial areas of South Wales. The pier was demolished in 1940 to allow nearby gun batteries a clear line of sight at any incoming enemy vessels. The recent photograph is of the rear of the war memorial looking down towards the sea.

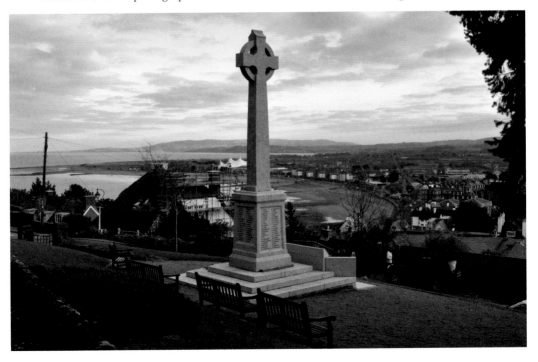

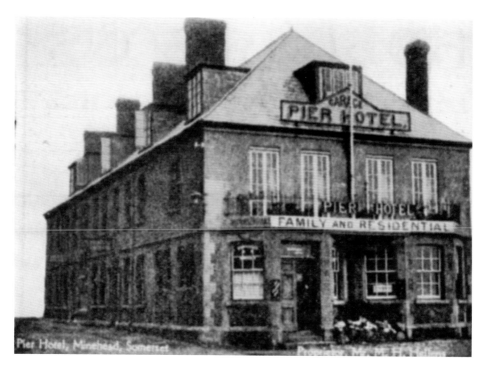

The Pier Hotel, Minehead, c. 1910
An image of what was, in the early years of the twentieth century, the Pier Hotel. Today it is home to the Old Ship Aground Inn.

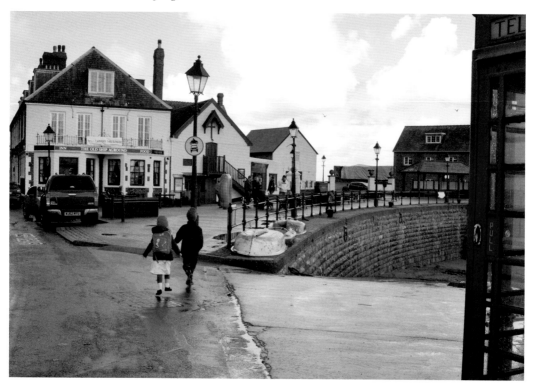

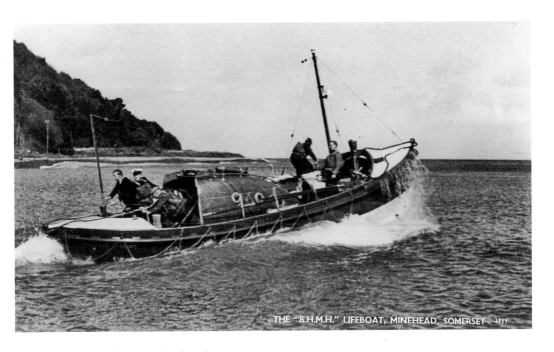

THE "B.H.M.H." LIFEBOAT, MINEHEAD, SOMERSET M11

The BHMH Lifeboat, Minehead, c. 1959

Minehead has had its own lifeboat station since 1901. These images feature a 1950s lifeboat out in the Bristol Channel (above) and the lifeboat station building itself (below). There are currently two inshore lifeboats operated from Minehead, a B Class rigid-hulled boat and an inflatable D Class and, as well as attending to emergency calls, visitors can watch them being launched every Sunday morning on training exercises.

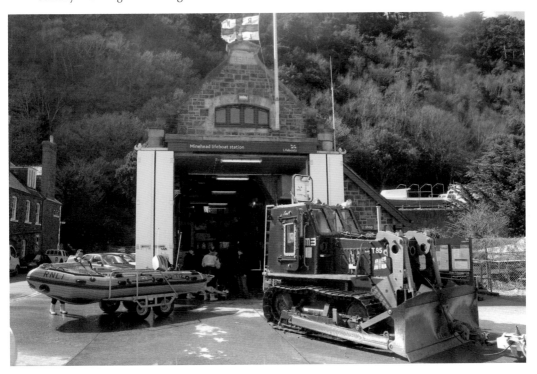

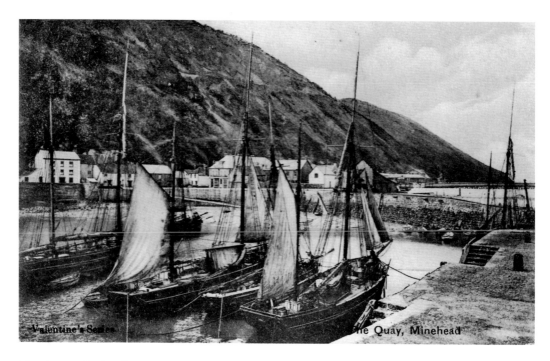

The Quay, Minehead, c. 1900

Until well into the twentieth century there was a flourishing trade in and around the harbour area. It was an important herring fishing port, from where salted herrings, wool, kelp, grain, and oak wood were exported. Limestone, coal and a wide variety of domestic goods and produce were imported from Bristol, ports in South Wales, and further afield. Although the commercial aspects of the harbour have long since disappeared, it is still home to numerous pleasure crafts and small-scale fishing vessels.

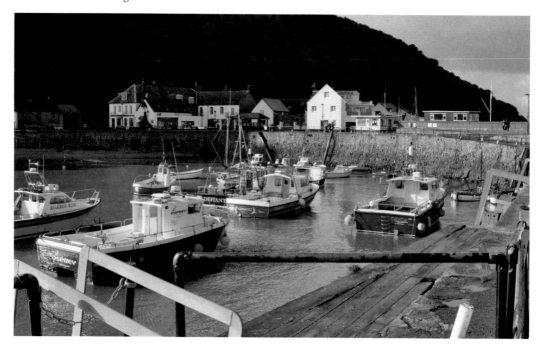

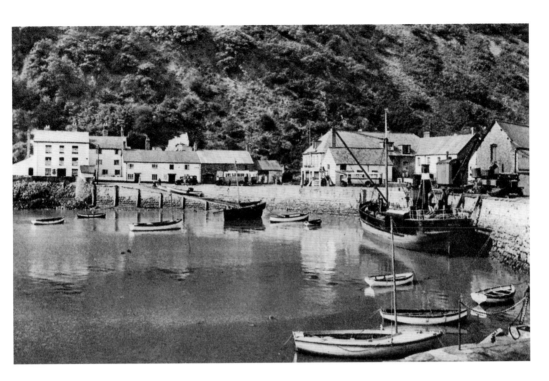

The Quay from the Harbour, *c.* 1930
Here is another old picture postcard view of the harbour. By this time the tall ships have all gone, and the harbour area is a much quieter and emptier place.

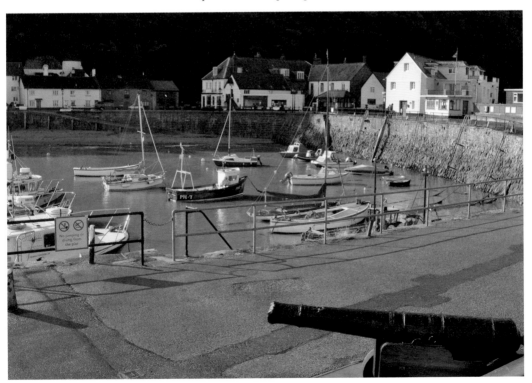

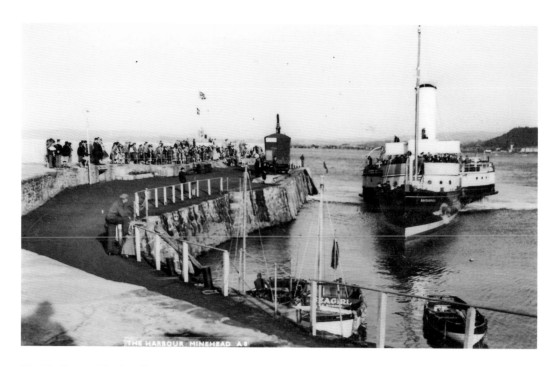

The Harbour, Minehead

A steamboat at the harbour during the heyday of Bristol Channel cruises. At this time regular trips were made to and from Barry, Penarth, and Clevedon, with cruises to Ilfracombe and Lundy Island. Even today, during the summer, the last ocean-going paddle steamer in the world, the *Waverley*, runs a programme of local trips and longer cruises to Ilfracombe and Lundy Island. Further details can be found at the website www.waverleyexcursions.co.uk. In the photograph below the Butlins holiday complex can be seen in the distance.

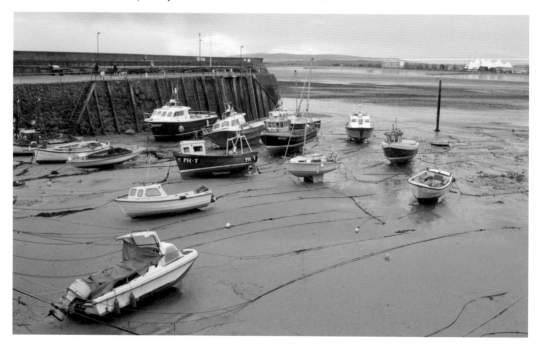

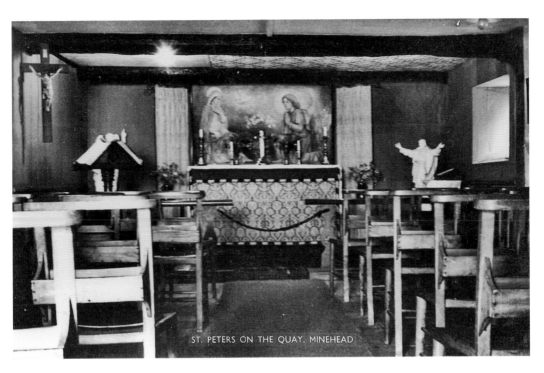

ST. PETERS ON THE QUAY, MINEHEAD

The Church of St Peter on the Quay, Minehead, *c.* 1955
Two different interior views of the unique chapel, located right next to what is now the Old Ship Aground Inn. This former Sailor's Home was converted into a chapel for sailors in 1907 and remains a place of worship to this day. The older image shows the altar area and the recent photograph shows the entrance.

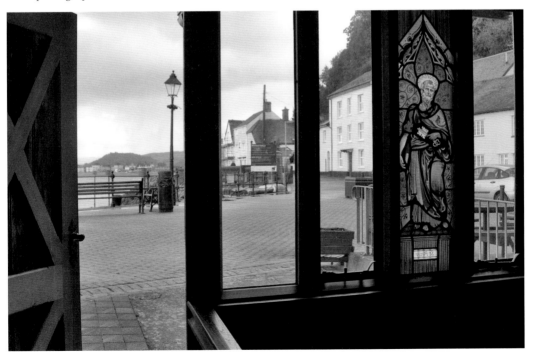

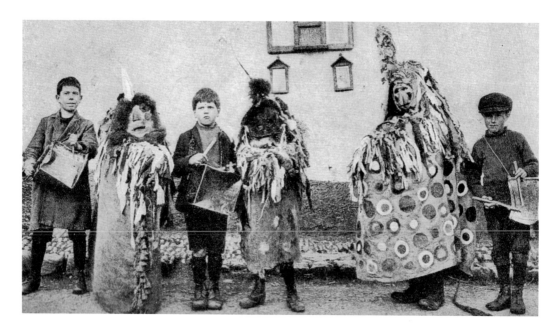

Hobby Horses, Minehead, c. 1910

During the first three days of May each year people dressed as hobby horses parade through the streets of Minehead and nearby Dunster, swinging around and dancing wildly. The horse is accompanied by people banging drums and often an accordion player. This is an ancient custom, which continues pretty much unchanged to this day. Theories as to the origin of this local tradition range from the horse being related to fertility and representing the 'King of May' to the custom beginning in order to frighten off Viking invaders. But whatever the origin of the Minehead Hobby Horse, it can certainly be traced back as far as the late eighteenth century.

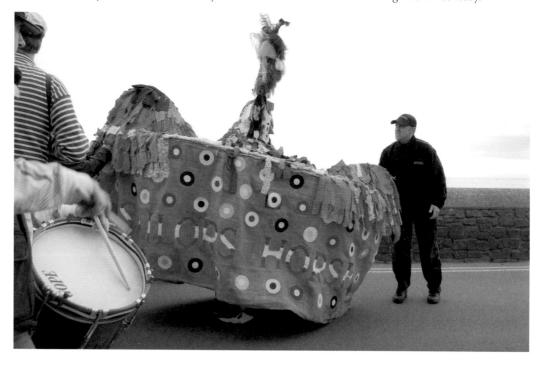

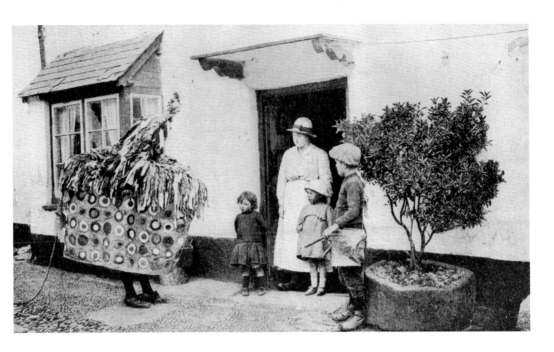

Hobby Horse Visiting a Cottage in Minehead, c. 1910

As part of the ancient May Day festivities, the Hobby Horse would call at cottages and houses collecting donations from householders. This practice continues today with proceeds going to local charities. The photograph below shows the horse outside the Old Ship Aground public house at the harbour.

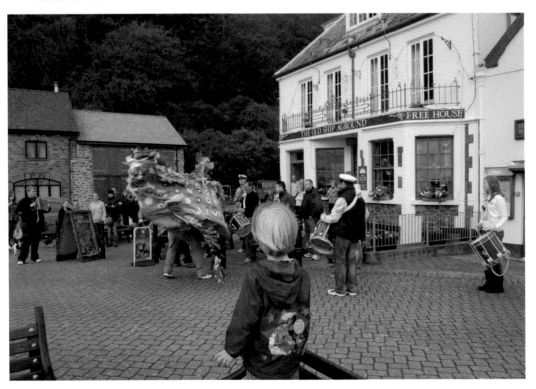

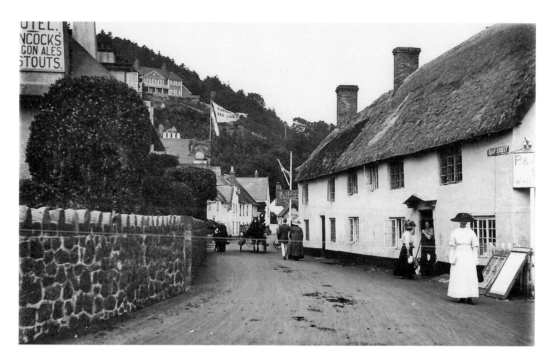

Quay Street, Minehead, *c.* 1900

These beautiful cottages were demolished in the 1920s to widen the access road to the harbour area and provide space for a promenade. Today the South West Coastal Path begins close to where the cottages once stood, and is marked by the sculpture seen in the photograph below.

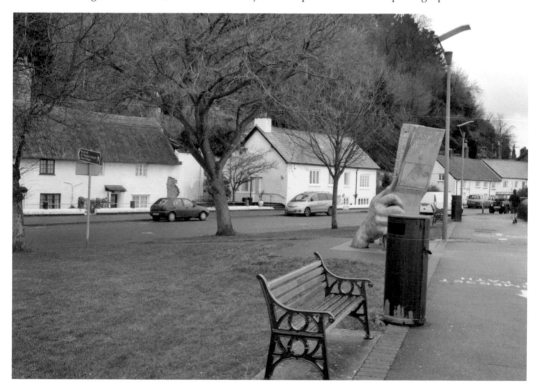

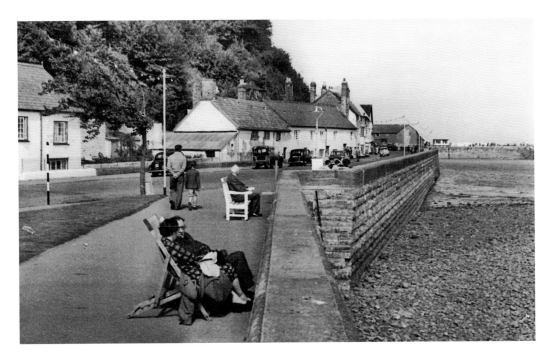

Quay Street, Minehead, *c.* 1959
Here we have tourists on the promenade looking out across the Bristol Channel in the direction of Wales. The photograph below was taken from the opposite side in the direction of the people seated in the earlier image.

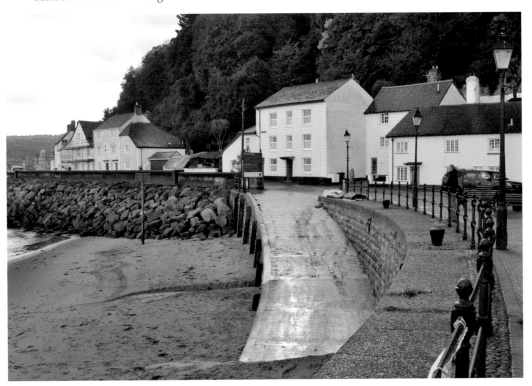

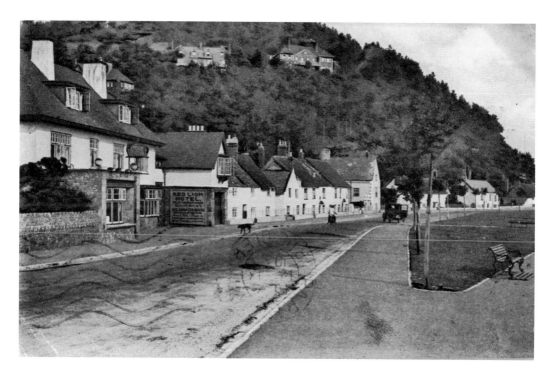

The Red Lion Hotel and Promenade, Minehead, *c.* 1930
'Hancock's celebrated beers' are advertised on a board outside the Red Lion Hotel in the early 1930s; North Hill is behind. The Red Lion is now the Quay Inn but still provides a quality pint to visitors and locals alike.

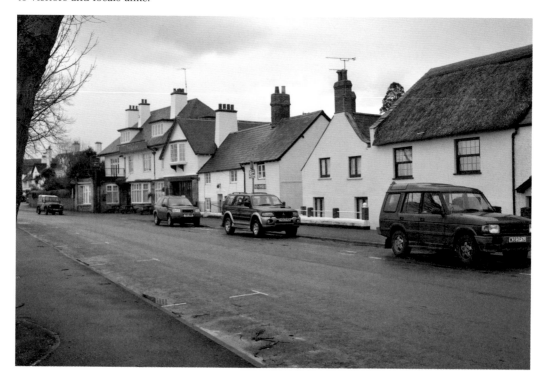

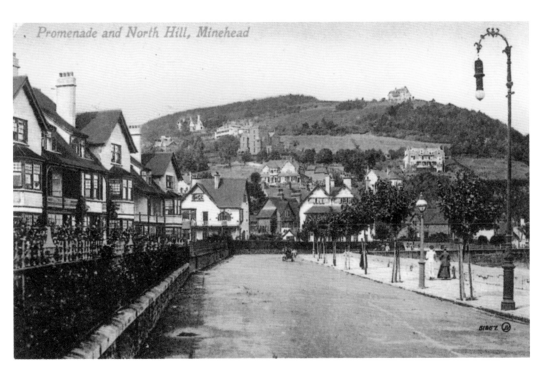

Promenade and North Hill, *c.* 1912
Fairly grand holiday accommodation along the promenade and part of the wonderfully scenic North Hill in Minehead. The sea wall and much of the promenade were constructed by the council in 1901.

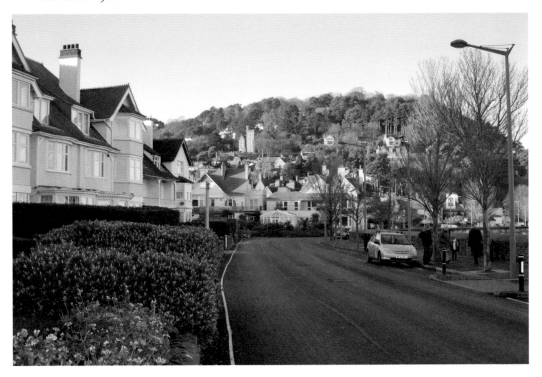

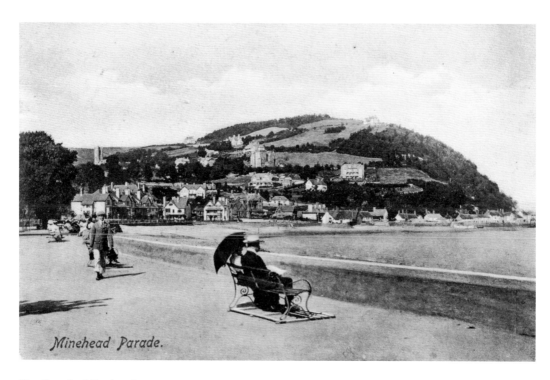

Minehead Parade.

The Parade, Minehead, *c.* 1905

Another look at the same part of town but from a different angle. The book stall shown in the present-day photograph is a regular summertime feature at the end of a private garden located behind where the people were seated more than 100 years earlier.

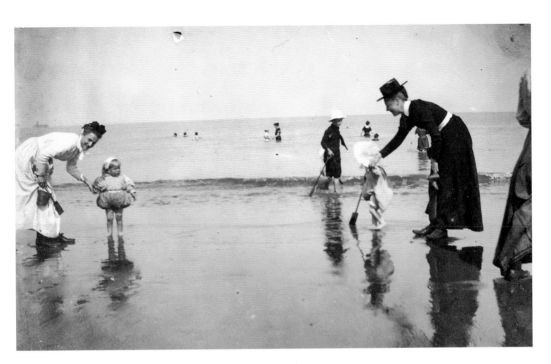

The Beach, Minehead, *c.* 1899
An early image from a family album depicting bathers and people on the beach at the very end of the nineteenth century. Note the bucket and spade and well-covered individuals. The image below shows the same area but, despite it being an extremely warm day in July, there are very few using the beach.

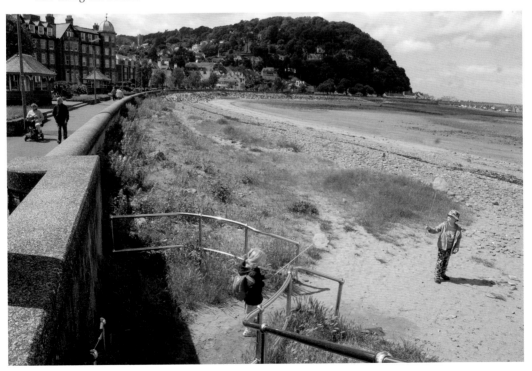

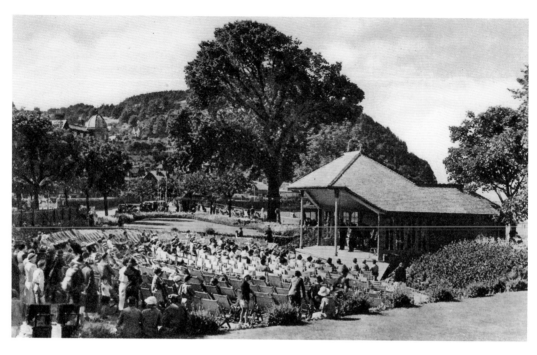

The Hotel Metropole, Minehead, *c.* 1910

Built in 1875 on the promenade seafront, the Metropole was probably Minehead's most luxurious hotel. The building remains a fine piece of architecture but is now dominated by the rather splendid Hobby Horse B&B, bar and ballroom.

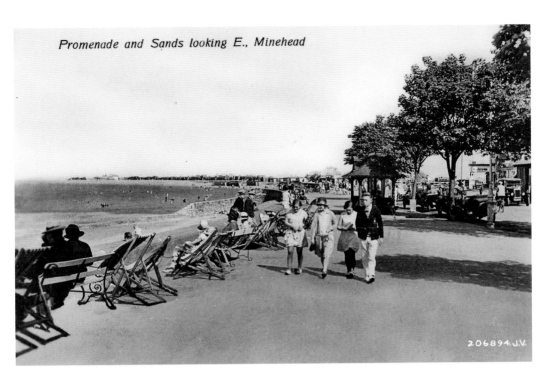

Promenade and Sands looking E., Minehead

206894 J.V.

Promenade and Sands, Minehead, *c.* 1925
Looking east along the promenade at tourists in deckchairs and people strolling. The photograph below features a Punch and Judy show taking place at the railway station, not far from where the earlier image was taken.

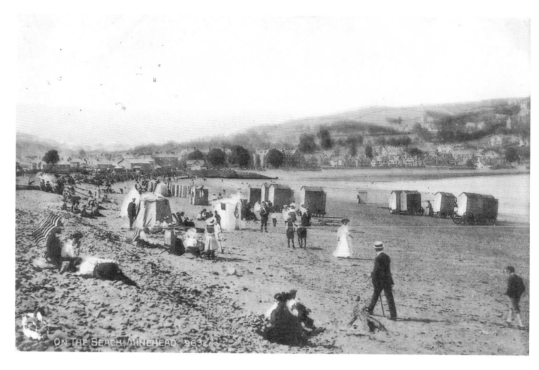

On the Beach, Minehead, c. 1905

Two different views of the beach. Close inspection of the first reveals a donkey being led by a young lad and numerous wheeled beach huts where bathers could change in privacy and perhaps escape the heat of the sun. In the second, seagulls are swooping down on a party of holidaymakers having a picnic on the beach. Judging by the number of gulls, pickings that day had been fairly slim elsewhere on the beach!

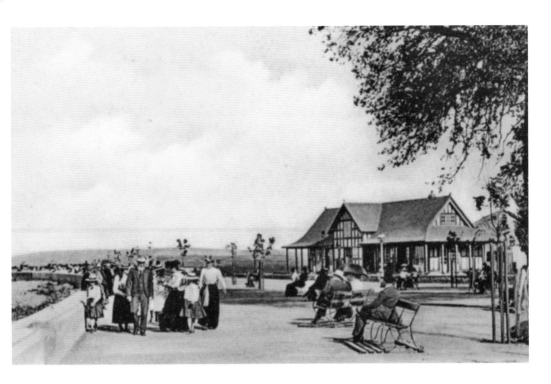

The Esplanade, Minehead, c. 1909

A genteel scene featuring well-dressed visitors making their way along the Esplanade in the early years of the twentieth century. The neon lights of the box-shaped amusement arcade and Butlins' pavilion tent structure along the seafront probably don't add add much to Minehead's look today.

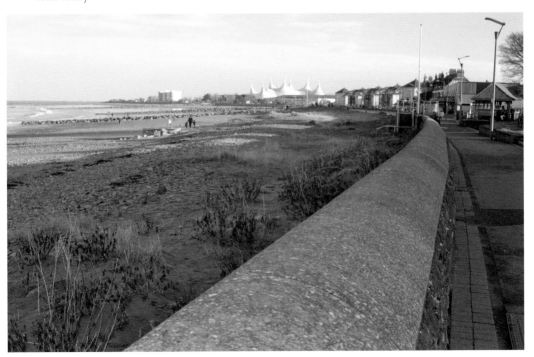

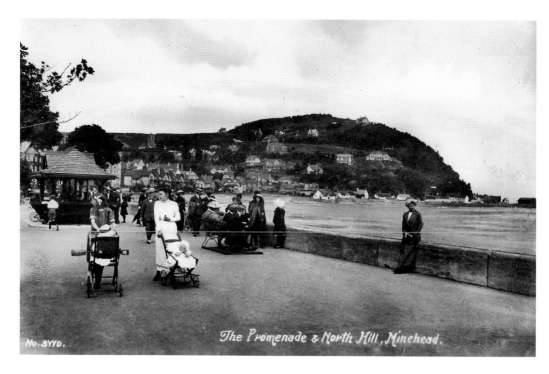

The Promenade and North Hill, *c.* 1910
Another view of Minehead's seafront in times past – babies in push-chairs and a bevy of wonderfully dressed holidaymakers with North Hill as a scenic backdrop. It would be interesting to contrast the housing development on North Hill and the change in visitor numbers past and present.

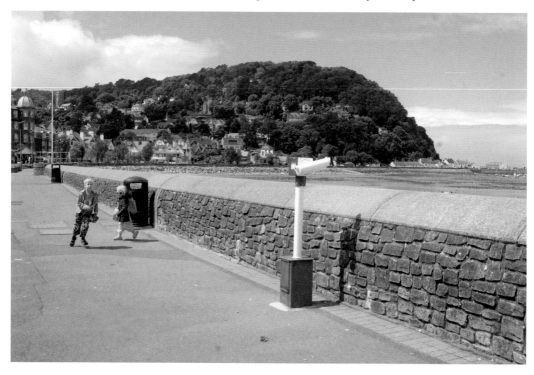

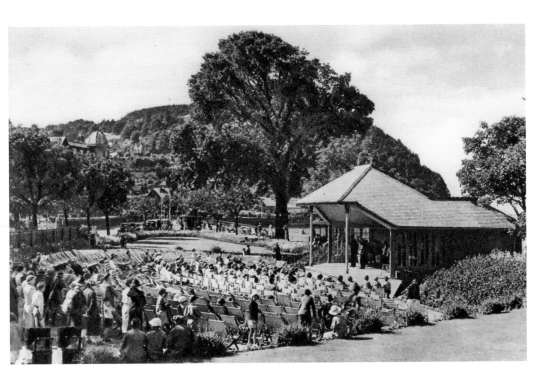

Jubilee Gardens, Minehead, *c.* 1920

In the earlier image holidaymakers are being entertained at the Jubilee Gardens pavilion on the seafront. In the recent photograph we see its present-day incarnation as the rather splendid Jubilee Gardens Café, which offers everything from tasty all-day breakfasts through to ice cream and a cup of tea. Crazy golf can now be played where visitors once sat in deckchairs to take in the sun and be entertained by bands and comedy turns.

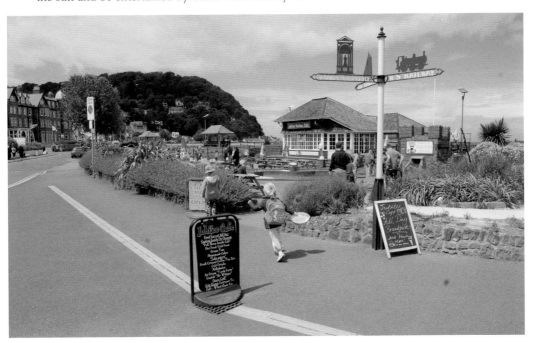

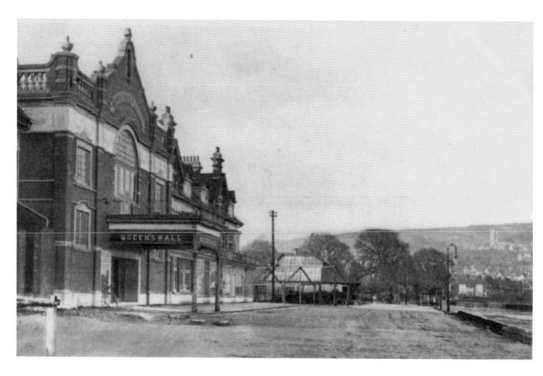

Queen's Hall, Strand Promenade, c. 1914

Here we contrast the Queen's Hall as it looked just after it was built in 1914, as a venue with stage productions alternating with films, with the sadly unused and boarded-up Queen's Hall of today.

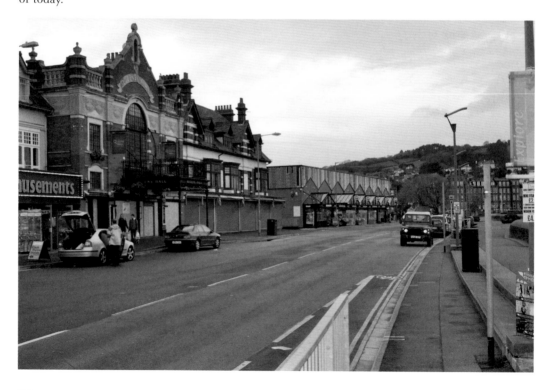

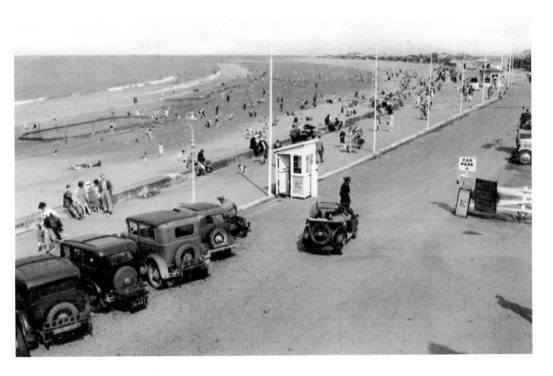

Beach and Promenade, c. 1931

A super 1930s picture postcard featuring cars of the time and a traffic barrier in use on what was a private road along the beach. There is no sign of the Butlins holiday camp in the distance as there was a brickworks on the site before the camp was developed. The present-day photograph depicts a popular activity for many of Minehead's visitors today – the amusement arcades!

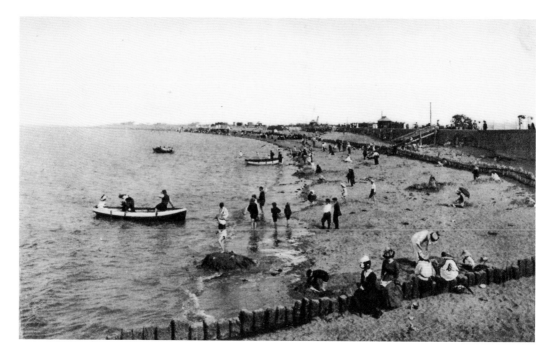

The Bathing Beach, Minehead, *c*. 1910
A busy beach scene from the Edwardian era contrasted with an emptier beach, which nowadays is more the norm. Ponies and donkeys gave rides to visitors along the beach for many years but are unfortunately entirely absent now. Holidaymakers seeking such thrills now have to travel to the nearby seaside resort of Burnham-on-Sea to experience a donkey ride on the beach!

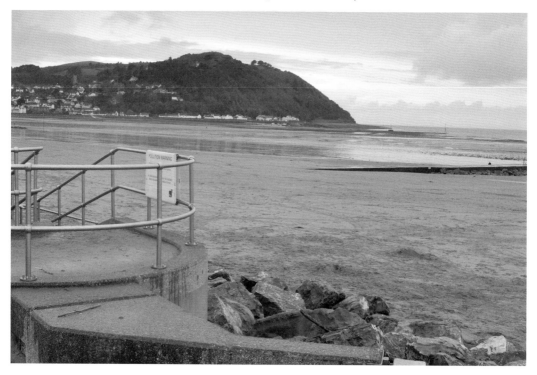

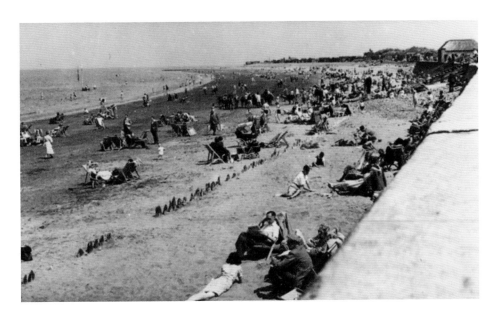

Minehead Sands, *c.* 1955
Another picture-postcard look at the beach, coupled with a photograph of the entrance to
Butlins – somewhere that tends to dominate much of Minehead today.

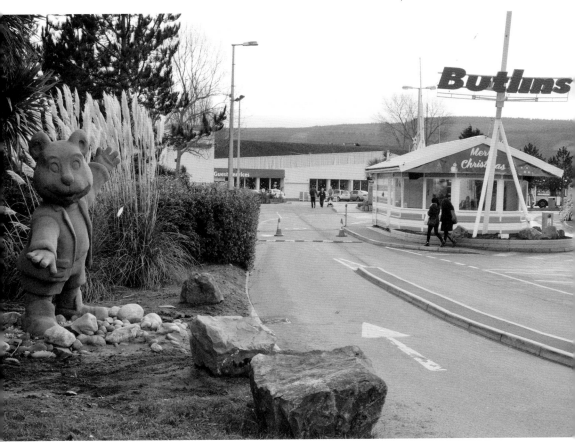

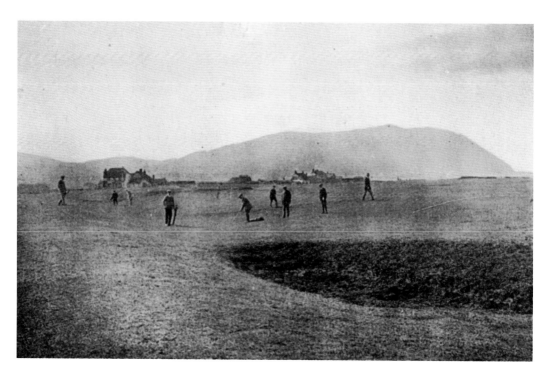

The Golf Course, Minehead, *c.* 1900

The Minehead & West Somerset Golf Club was founded in 1882, and is the second oldest golf club in the South West. It is an 18-hole, 6,153-yard, par 72 course. On several occasions in its history the course's close proximity to the sea has caused damage to the clubhouse, and due to the encroachment of the sea various changes have had to be made to the course.

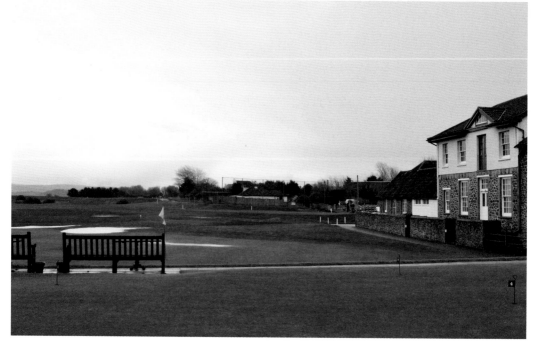

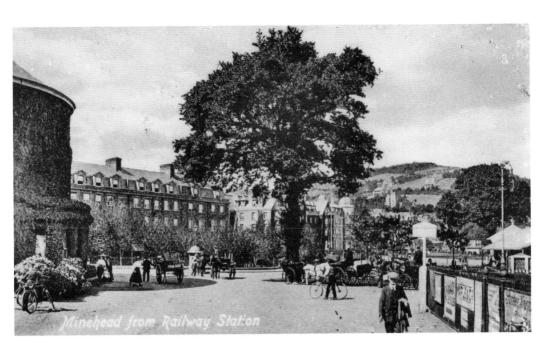

Minehead from Railway Station

Minehead from the Railway Station, *c.* 1909

The railway station was opened on 16 July 1874 by the Minehead Railway. It is located on the seafront, close to the town centre. The station consists of a wide, single platform with tracks on both sides. The main track on the seaward side is platform 1, while platform 2 stops short of the stone-built station buildings. The old goods shed is opposite the station building and is now used as a locomotive workshop. Opposite platform 2 is the turntable, overlooked by a super little café operated by the railway. The buildings on the platform include a booking office and a shop selling souvenirs. Trains run between Minehead and Bishops Lydeard, near Taunton, at weekends and on some other days from March to October, daily during the late spring and summer, and on certain days during the winter.

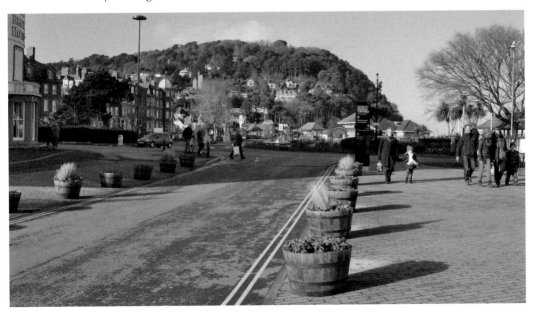

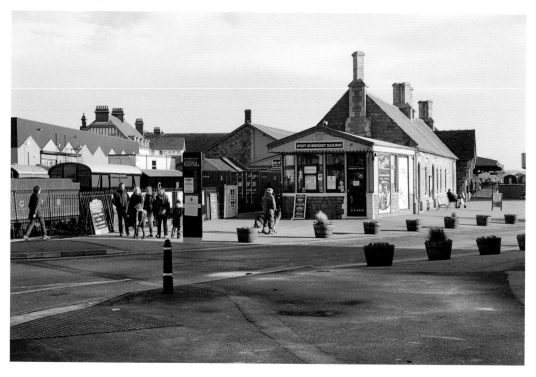

Coaches at Minehead Station

Coaches at the Railway Station, Minehead, c. 1907
Horse-drawn carriages and coaches at the railway station, terminus of the Taunton to Minehead branch line, contrasted with a photograph of how the area looked on one wet day in December 2013.

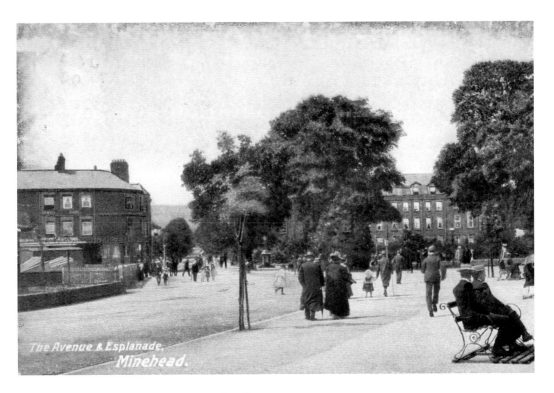

The Avenue and Esplanade, Minehead, _c._ 1910
Looking towards the Beach Hotel and up The Avenue, Minehead's main shopping street.

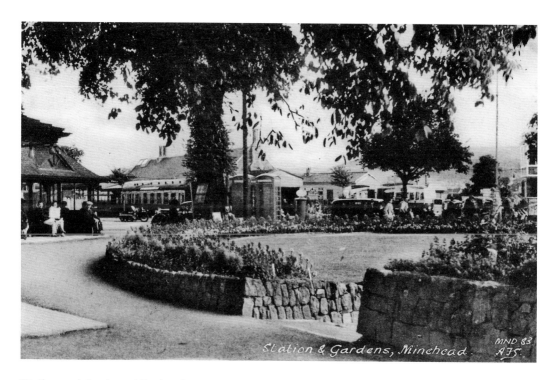

Station and Gardens, Minehead, c. 1930
Here we see the railway station from close to the sea wall. The picture postcard was posted from Minehead to an address near Cardiff and describes what a wonderful time they are having in Somerset. The writer even recommends the local scrumpy cider!

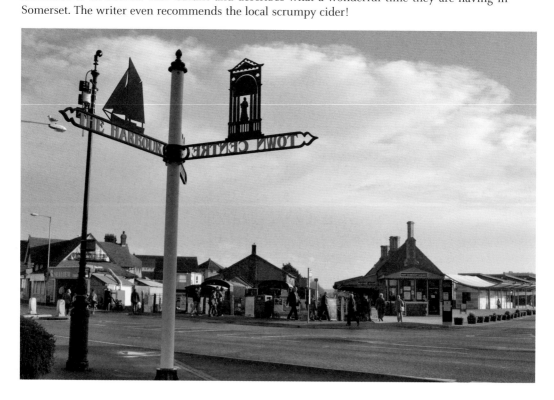

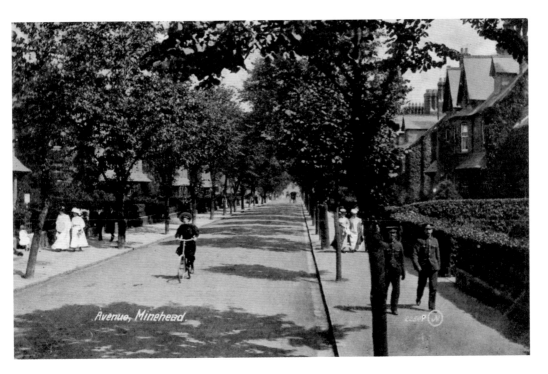

The Avenue, Minehead, c. 1914

In the early view, two uniformed soldiers are strolling down The Avenue and a lady cyclist is cycling in the middle of the road – most definitely not sights you would see very often in The Avenue today!

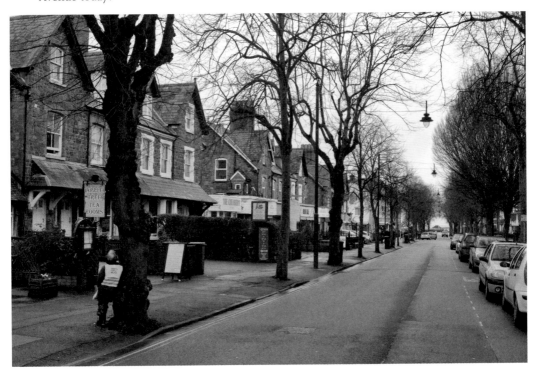

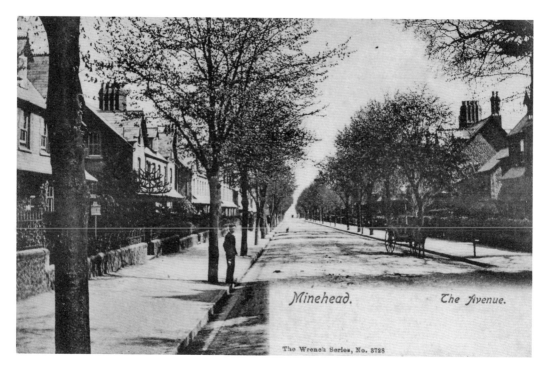

Minehead. The Avenue.

The Wrench Series, No. 3728

The Avenue, c. 1905

Here is an even more deserted picture postcard view of a tree-lined Avenue. As can be seen in the present-day photograph, The Avenue is now a much busier place, with a plethora of shops both large and small, cafés, and other commercial enterprises.

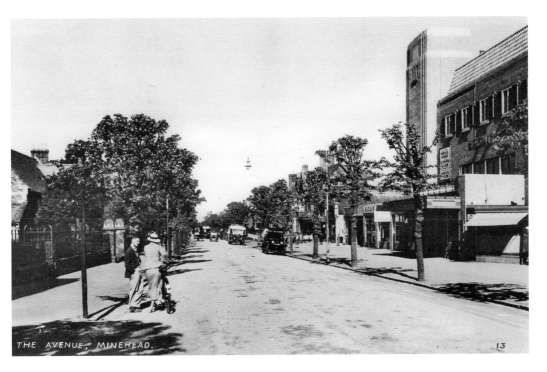

THE AVENUE, MINEHEAD. 13

The Regal Cinema and Ballroom, Minehead, c. 1937
The Regal was built in 1934 as a 1,600-seat theatre and cinema. Today the former ballroom on the ground floor houses a Poundland outlet, but upstairs there remains a large auditorium where small- and large-scale performances of drama, ballet, contemporary dance, classical and all styles of music still take place.

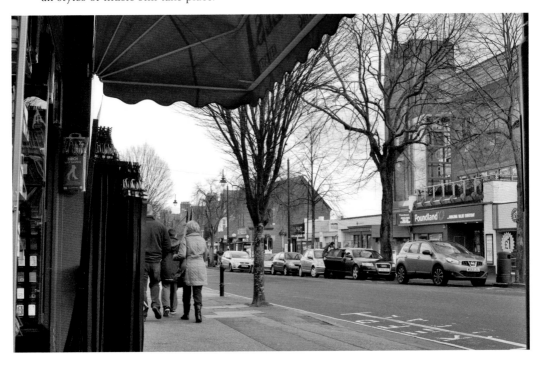

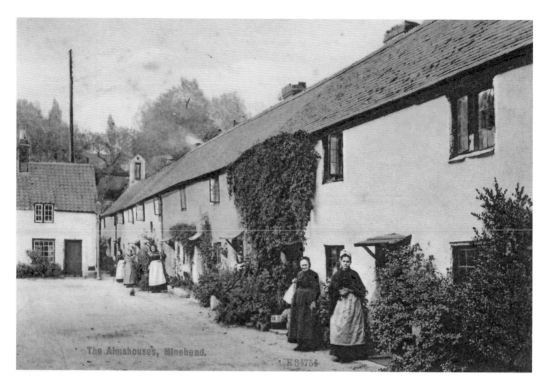

The Almshouses, Minehead, *c.* 1900
The seventeenth-century Almshouses given to the town by master mariner Robert Quirke. Several memorials to the seafaring Quirke family can be seen in St Michael's church.

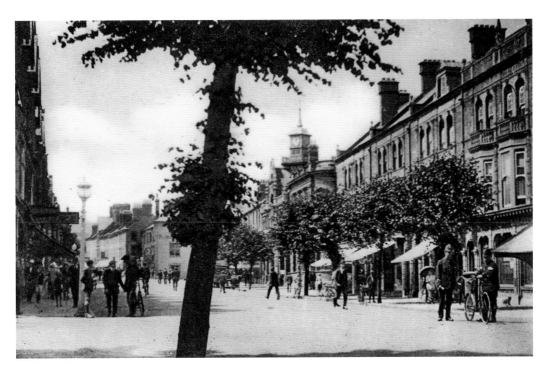

The Parade, Minehead, *c.* 1910
Two policemen stand watch over a motor-free Parade in the early years of the twentieth century.
The clock tower of the town hall is clearly visible in both photographs.

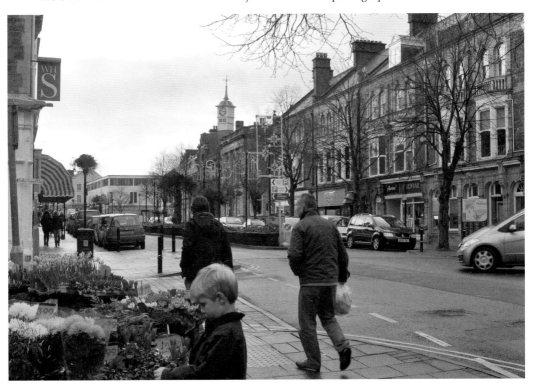

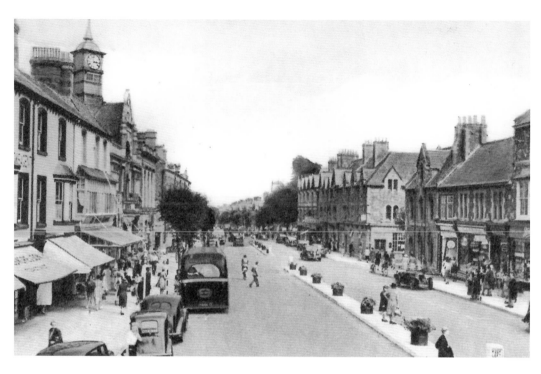

The Parade, Minehead, c. 1935
Another old picture-postcard view of The Parade. This time the photographer was looking down the street in the direction of The Avenue and seafront. The present-day photograph is of the old Priory, a Grade II listed building, which is located where The Parade meets with The Avenue and Priory Street.

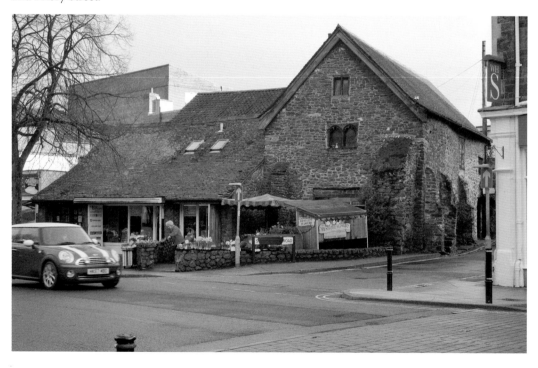

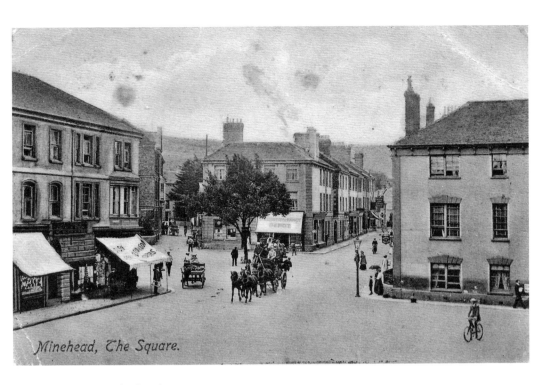

Minehead, The Square.

The Square, Minehead, c. 1907

Here we have an Edwardian-era view from The Parade, looking towards Wellington Square and Park Street beyond, along with a recent photograph from Park Street across the Square and toward The Parade. In the earlier image the 'four-in-hand' Lynton to Minehead coach is centre stage.

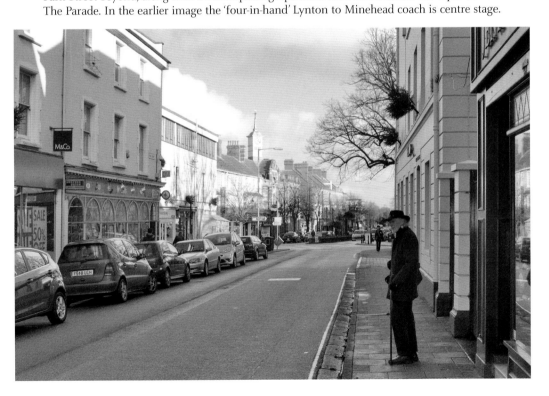

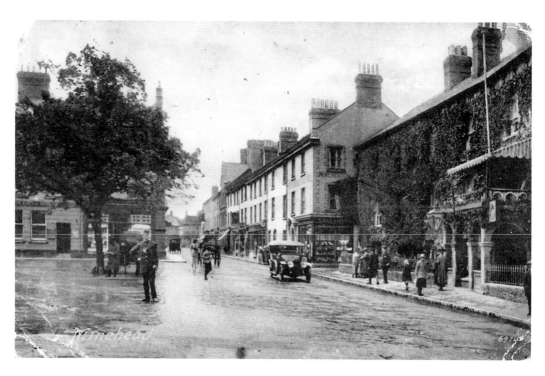

Wellington Square, Minehead, c. 1910

A similar view of the Square and Park Street but this time with part of the here ivy-clad Plume of Feathers Hotel visible. Unfortunately, this fine and important building has long been demolished and replaced with quite the ugliest of buildings. So much so that the recent photograph has been taken from a slightly different vantage point!

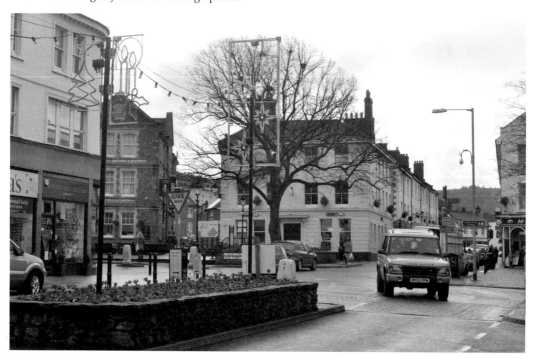

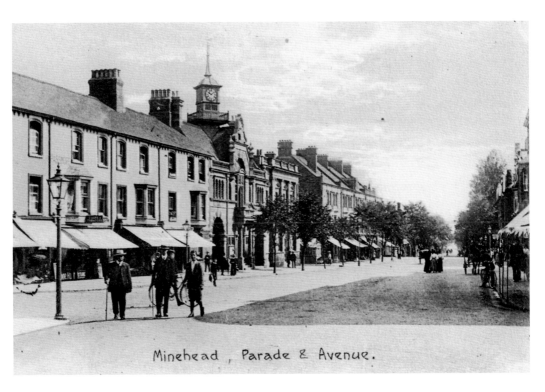

Minehead , Parade & Avenue.

Parade and Avenue, *c.* 1905
An interesting view of The Parade looking toward The Avenue coupled with a recent photograph taken from a little further back in the Square.

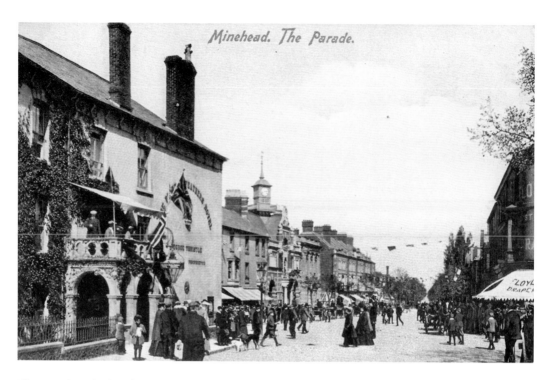

The Parade, Minehead, c. 1907

The sadly demolished Plume of Feathers Hotel on the left with the photographer looking down The Parade in the direction of The Avenue where, in the distance, Minehead's hospital was located. The photograph below shows the building that housed the hospital, which is now empty awaiting development.

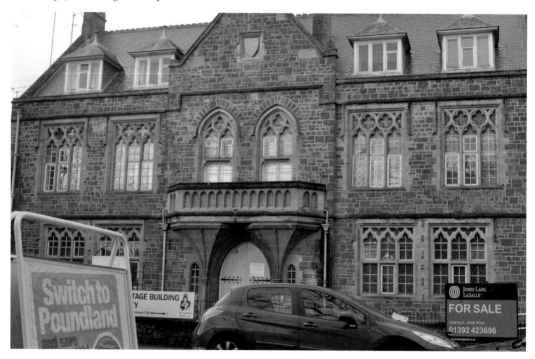

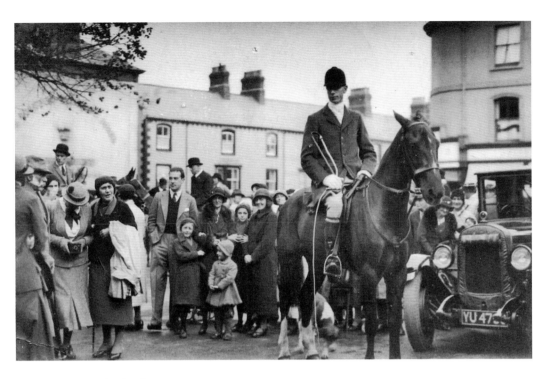

Hunt Meet in the Square, *c.* **1925**

The hunt and followers gathered together in a mid-1920s photograph above, combined with one of the nearby Market House/Town Hall building below. This Grade II listed building was once a covered market, but is now home to a café and a retail unit, with the town council offices on its upper floors.

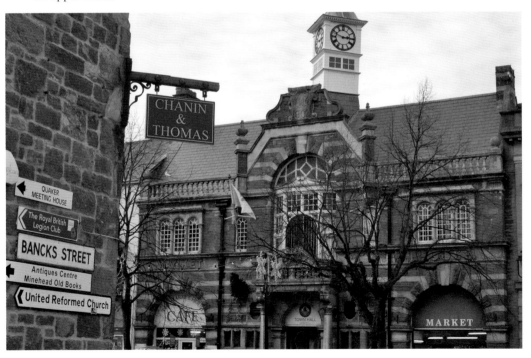

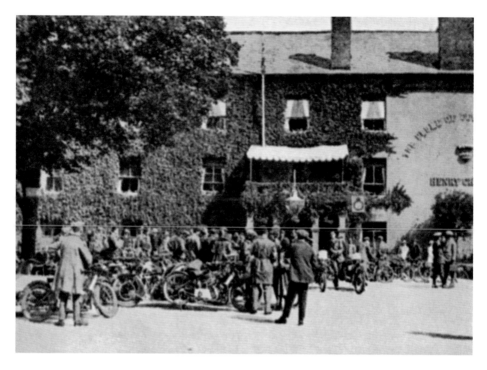

Motorcycle Club Meeting Outside the Plume of Feathers Hotel, c. 1910

A group of motorcycle enthusiasts pictured in the Square, fresh from a run up and down nearby Porlock Hill. This very steep hill, with gradients of up to 1 in 4 and hairpin bends, would have been quite a challenge for motorbikes of this period! The present-day view is of terraced houses and shops in Summerland Road, which is a one-way street just off of The Avenue. This is a stone's throw from where the motorcycle meet took place more than a hundred years before.

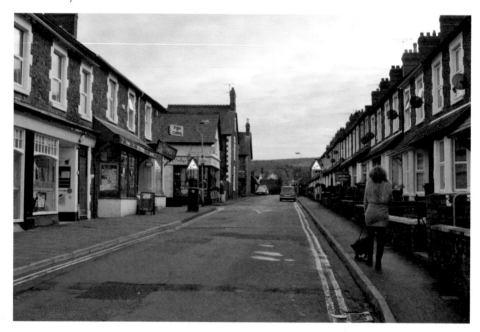

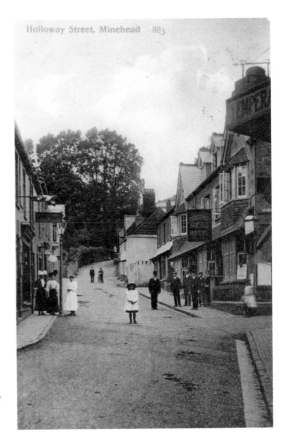

Holloway Street, Minehead, *c.* 1909
Here we have another view of a street in
The Parade part of town. This is Holloway
Street and, as can be observed, the scene
remains remarkably unchanged today.

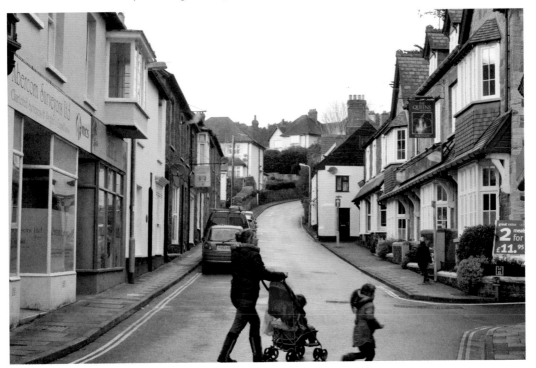

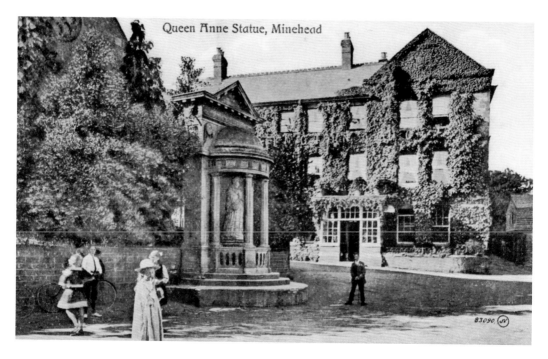

Queen Anne Statue, Minehead, c. 1906

Another virtually unchanged corner of Minehead. The statue of Queen Anne we see to the left of each picture was commissioned by Sir Joseph Bancks, the MP for Minehead, in 1719. The commission was to make a similar statue to that in St Paul's Cathedral. When completed, this over-life-size standing figure was originally placed in St Michael's church, but moved to its current location in Wellington Square in 1893.

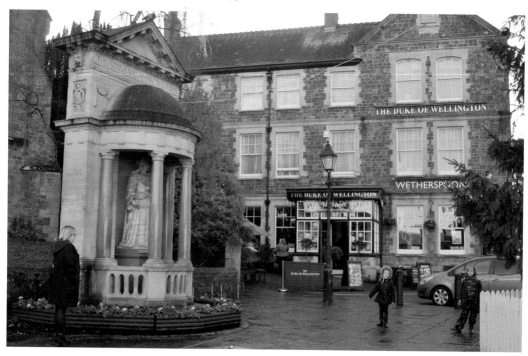

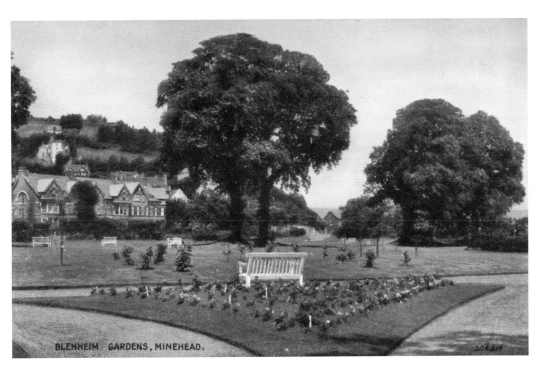

BLENHEIM GARDENS, MINEHEAD.

Blenheim Gardens, Minehead, *c.* 1910
Blenheim Gardens are in the centre of town, right behind The Avenue, linking the town to the seafront. The gardens are maintained by West Somerset District Council and were originally purchased from the Luttrell family of Dunster in 1911 for the public to enjoy.

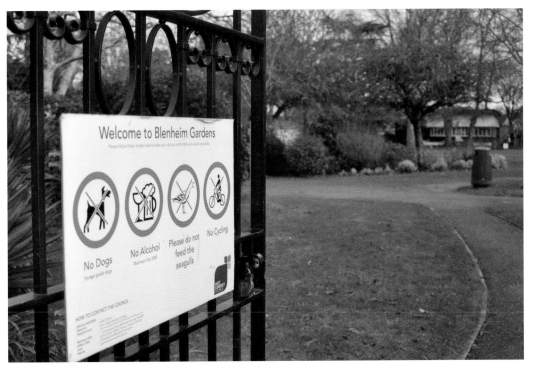

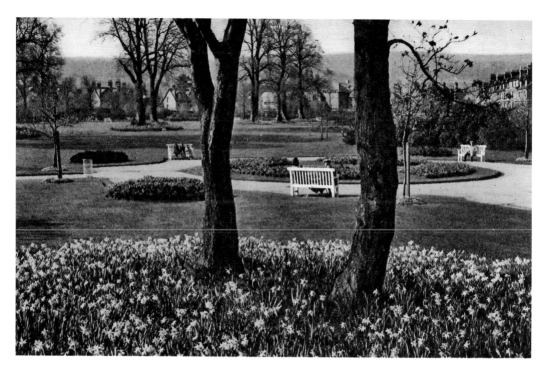

Blenheim Gardens, *c.* 1930

These pleasant, well-kept public gardens are open all year, and have a café, an 18-hole putting course, and a bandstand, which still hosts Sunday afternoon band concerts throughout the summer.

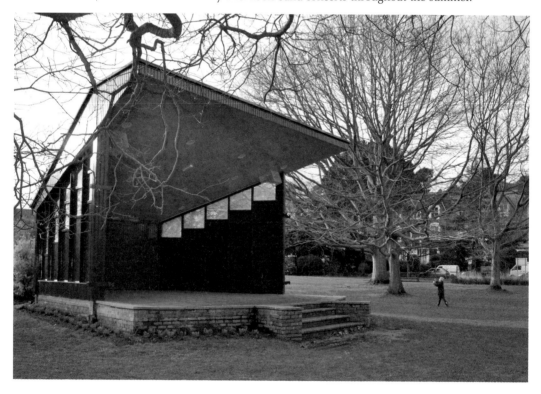

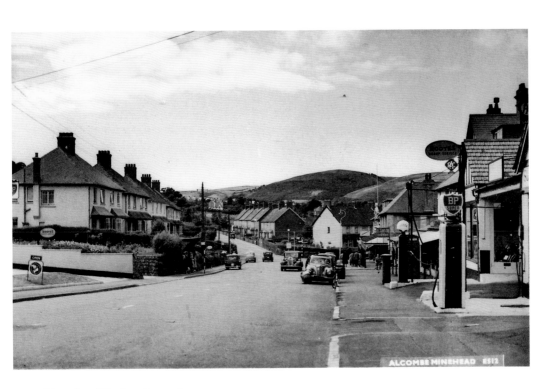

Alcombe, Minehead, *c.* 1964

The Rootes Group service station in Alcombe Road as it was in the 1960s coupled with a recent photograph of the same part of Minehead. Interestingly, the garage appears to have both Shell and BP branded fuel on sale at different pumps.

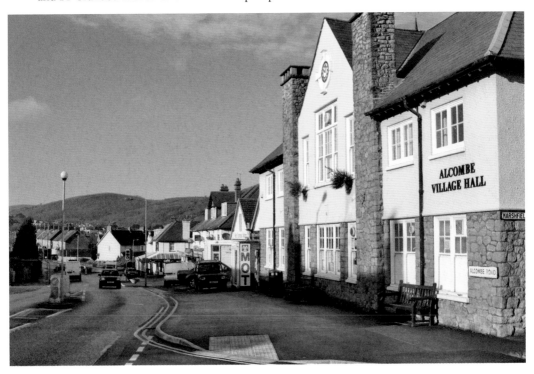

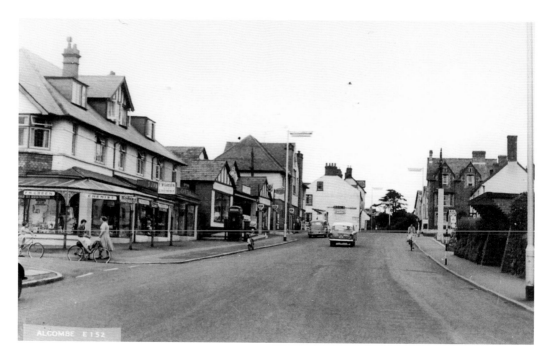

Alcombe, Minehead, c. 1965

A similar view of the same street, but taken from the opposite direction, looking toward Dunster. The large building seen to the left of the present-day photograph houses a Co-operative food store. Further up the road the spot occupied by a chemist shop is still offering much the same service and products some fifty years on.

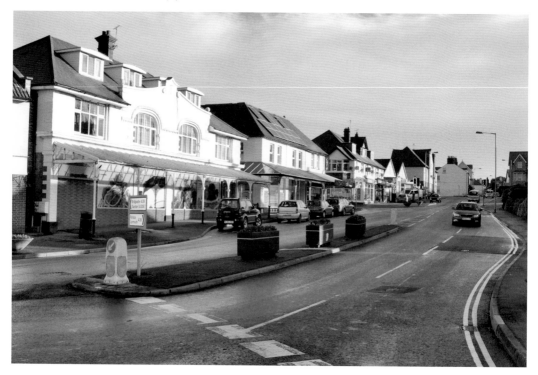

Dunster

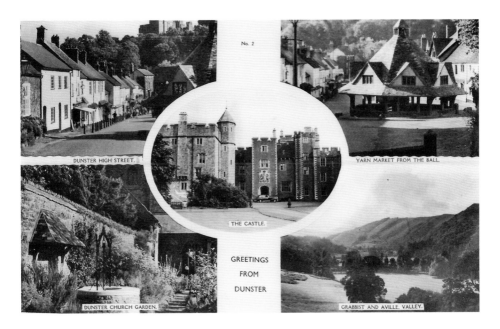

Dunster

Moving on, we now arrive at the picturesque village of Dunster, some 2 miles south-east of Minehead. It is undoubtedly the finest and best preserved medieval village in England.

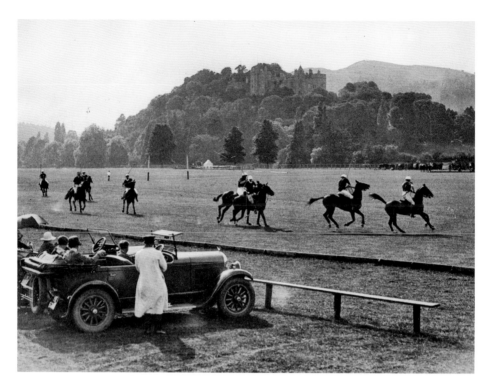

The Polo Grounds and Castle, Dunster, August 1926
A polo match being played in the grounds below Dunster Castle. Polo was a popular pastime in Dunster up to the Second World War and polo players came from all over the world to play. These included Winston Churchill, the Maharajah of Jodhpur, various dukes, and numerous other well-known personalities of the time. The castle is of Norman origin, and came into the possession of the Luttrell family in the late fourteenth century, where it remained until it was given to the National Trust in 1976.

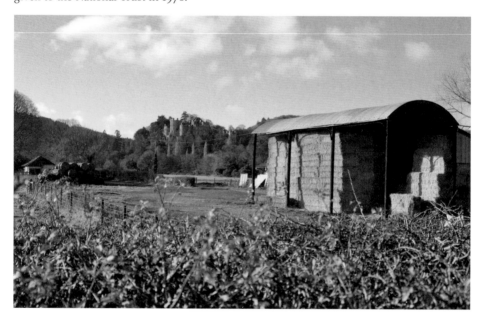

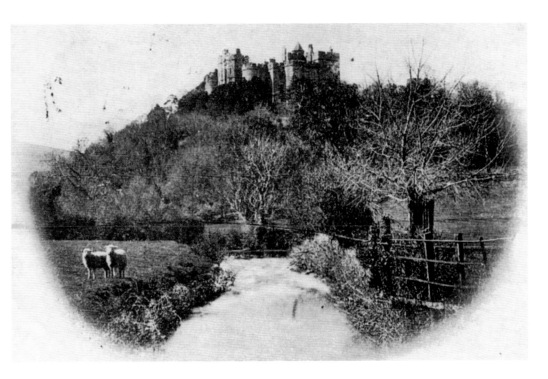

Dunster Castle and Trout Stream, *c.* 1902
The fairy-tale-like Dunster Castle looks out over Exmoor and the Bristol Channel and is home to England's oldest lemon tree. There has been a castle on the site for over 1,000 years, and it is a Grade I listed building and scheduled monument.

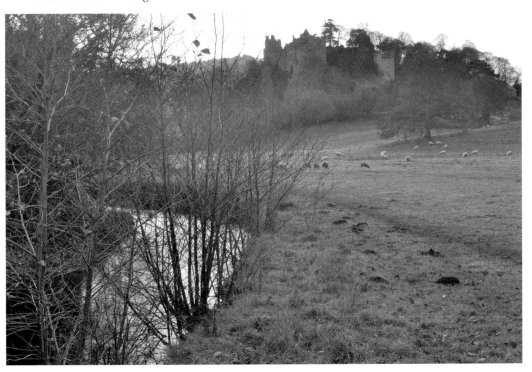

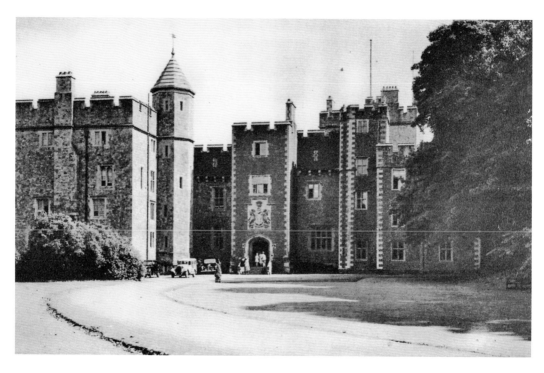

Dunster Castle, *c.* 1935

The castle and gardens are owned by the National Trust, an organisation founded in 1895 to look after places of historic interest or natural beauty permanently for the benefit of the nation. When in the area, a visit to either the grounds or the castle itself has to be on any 'must-do' list!

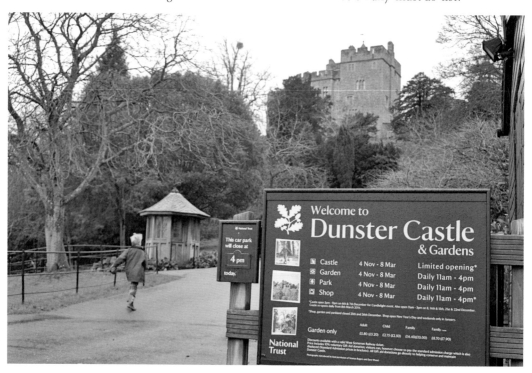

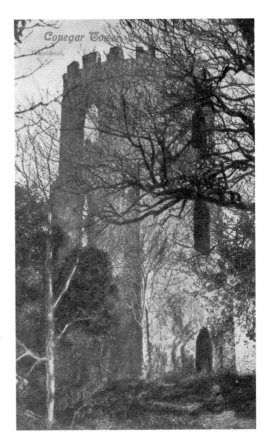

Conygar Tower, Dunster, c. 1905
This folly tower is situated on the top of
Conygar Hill and overlooks the village. It
was commissioned by Henry Fownes Luttrell
and designed and built by Richard Phelps in
1776. Reports indicate that the Luttrell family
had to spend a considerable sum on scrumpy
cider and 'entertainment' to encourage the
workmen to work at a sufficient speed on
the construction! The tower was long used
as a landmark for shipping and is visible for
miles around.

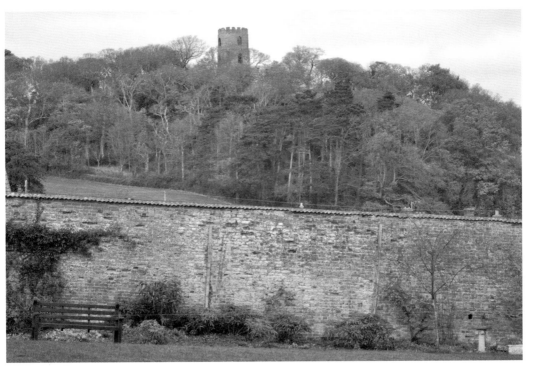

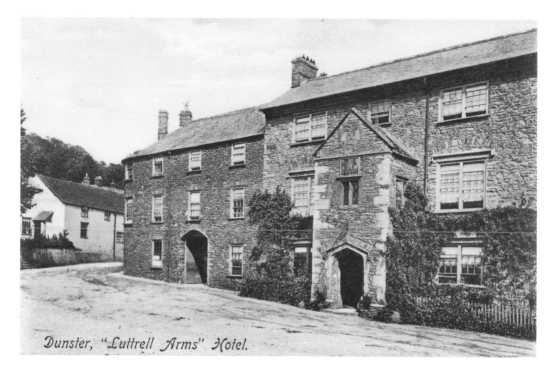

Luttrell Arms Hotel, *c.* 1910

At the top of the High Street is the Luttrell Arms. It was once a guest house for the Abbots of Cleeve and its oldest section dates back to the fourteenth century. Today it is a flourishing three-star, twenty-eight-room hotel, with a claim to fame as the location in Agatha Christie's *The Cornish Mystery*, where Hercule Poirot confronts the murderer in one of the hotel's bedrooms.

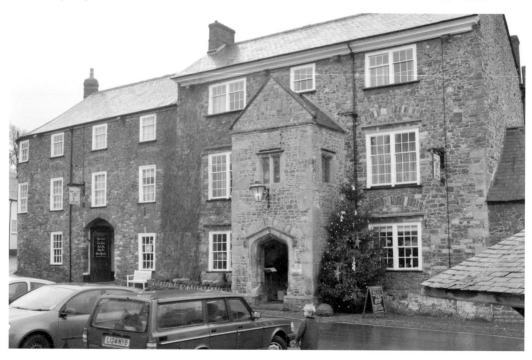

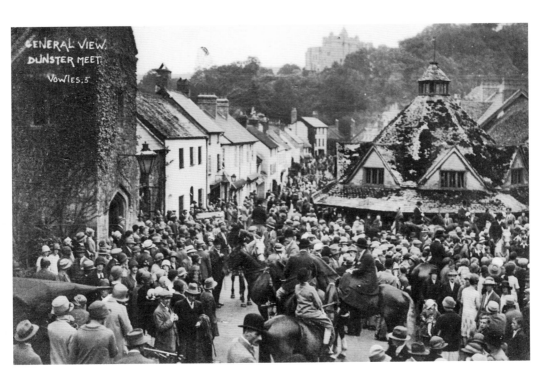

General View of Dunster Meet, *c.* **1911**

Here we have a picture postcard view of a meeting of the Devon and Somerset Staghounds as seen from the Ball, looking down the High Street toward the Castle. The photographer was Alfred Vowles who produced a vast number of images of the whole of the West Somerset area during this period.

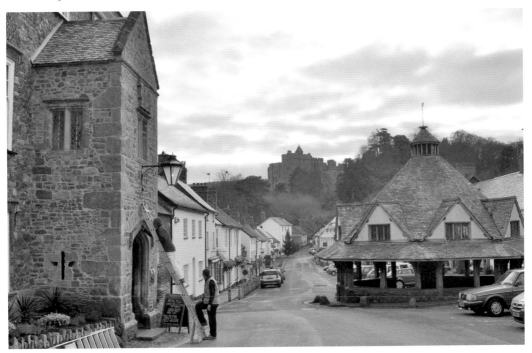

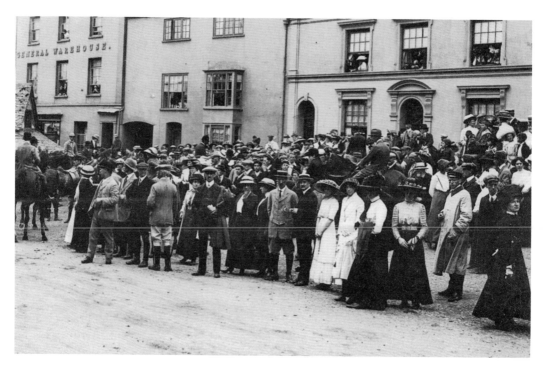

Hunt Followers, Dunster, *c.* 1910
Hunt members and hunt followers gather outside the Yarn Market Hotel.

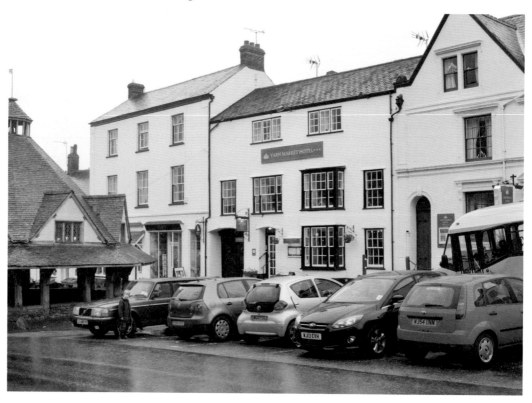

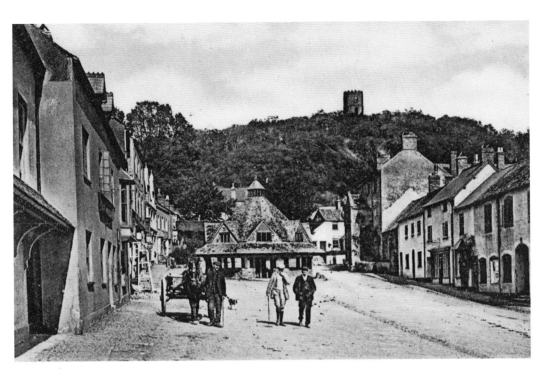

Market House and Conygar Tower, Dunster, c. 1901
Looking down the High Street toward the Yarn Market (Market House) and Conygar (Conegar) Tower. It was from up on the tower hill that the hymn 'All Things Bright and Beautiful' was composed by Cecil Alexander in the mid-nineteenth century. The view of Dunster and the surrounding area was said to be her inspiration.

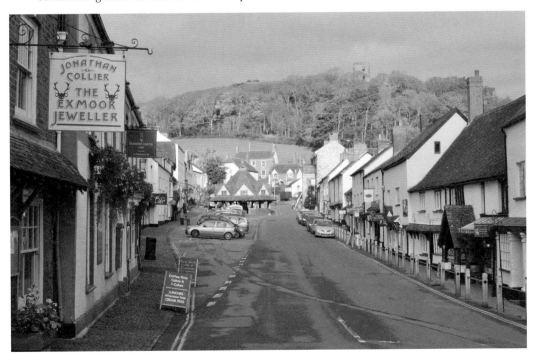

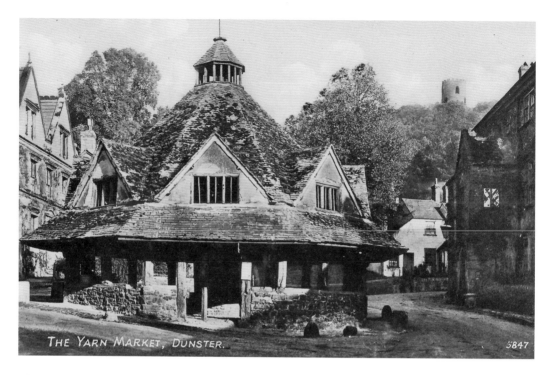

THE YARN MARKET, DUNSTER. 5847

The Yarn Market, Dunster, *c.* 1910

This fascinating structure was built at the end of the sixteenth century as a market to shelter wool and yarn traders and their wares from the rain. It is octagonal in shape with a central stone pier that supports a heavy timber framework with a slate roof. The Yarn Market was damaged during the English Civil War and a cannonball hole in one of the beams can still be seen.

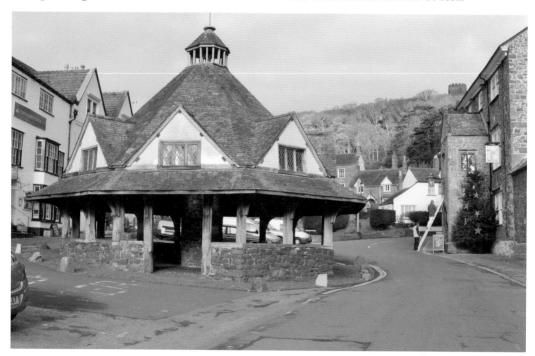

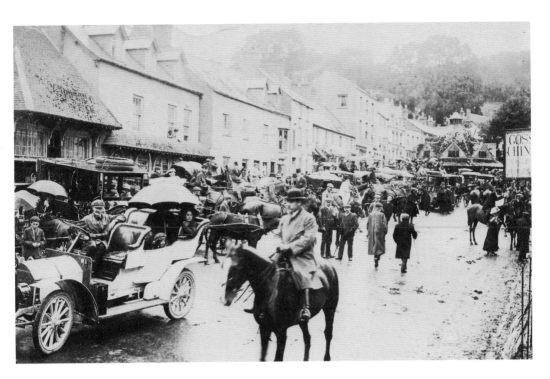

Hunt Meeting, Dunster, *c.* 1907
Here we have a marvellous photograph of a meeting of the Devon and Somerset Hunt in the High Street. The Yarn Market is in the distance.

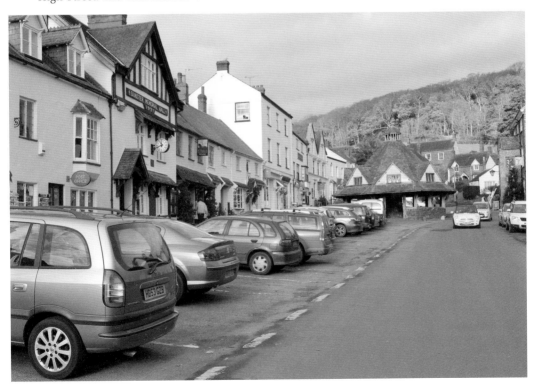

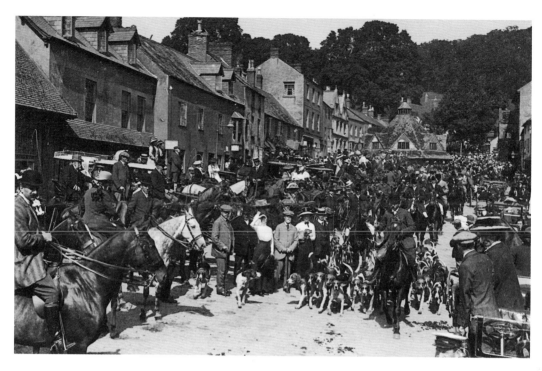

Hounds in the High Street, Dunster, *c.* 1908
Another meeting of the local hunt in Dunster's High Street. The recent photograph is of a similar part of the High Street but with the photographer pointing his camera in the opposite direction past the post office towards the castle.

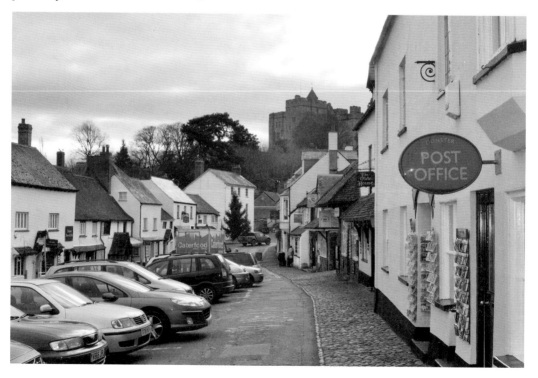

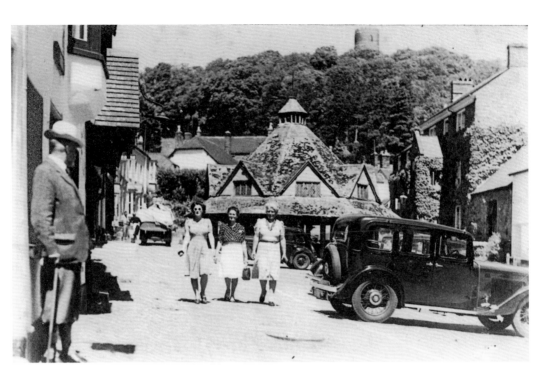

The High Street, Dunster, c. 1930
A snap from a family album of three ladies taking a stroll while an old gentleman takes in the sights! The photograph below was taken from exactly the same spot and, as can be seen, the view is almost unchanged.

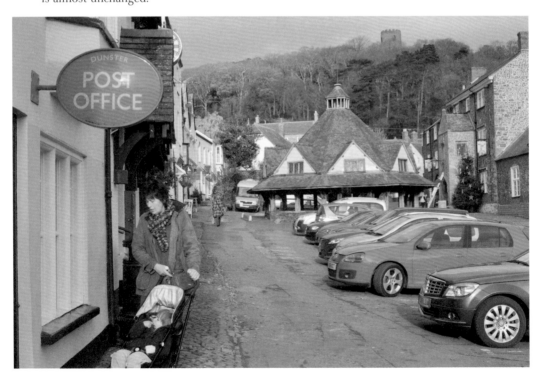

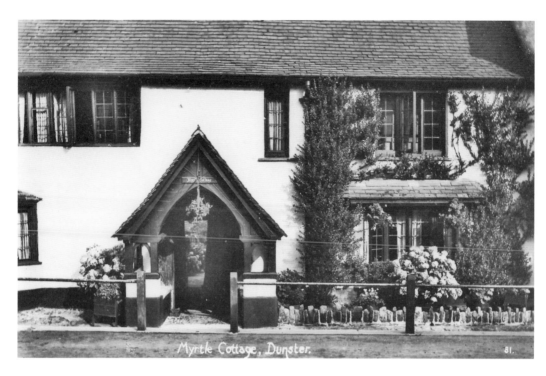

Myrtle Cottage, Dunster, *c.* 1935
Two images of one of the many beautiful and unspoilt buildings in the High Street. The cottage is currently a rather fine bed and breakfast establishment and on the day of our visit is receiving a coat of paint.

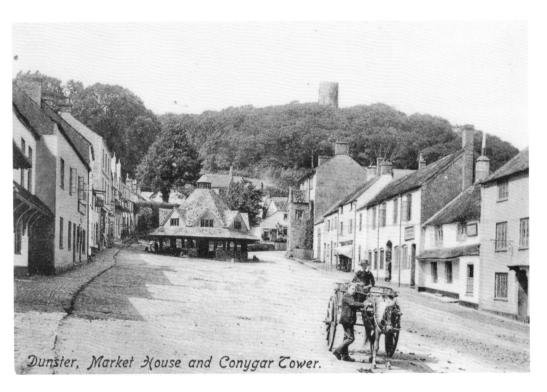

Dunster, Market House and Conygar Tower.

The High Street, Dunster, *c.* 1900
An early picture-postcard view looking up a very empty High Street toward Conygar Tower, coupled with a photograph of the same area on a wet afternoon in December 2013.

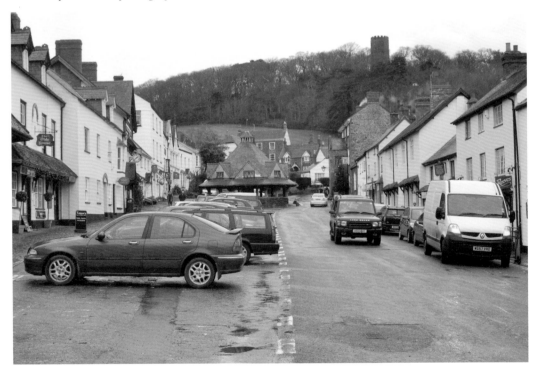

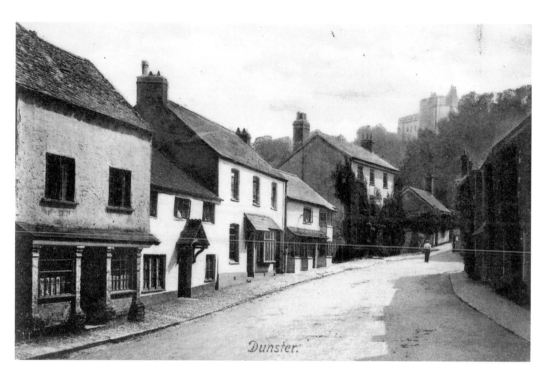

The High Street and Castle, *c.* 1920
Another look at the High Street – this time in the direction of what is now the Castle Coffee House, which incidentally has a lovely terrace garden and offers its customers a range of tasty hot meals and snacks (some of which were sampled soon after the recent photograph was taken).

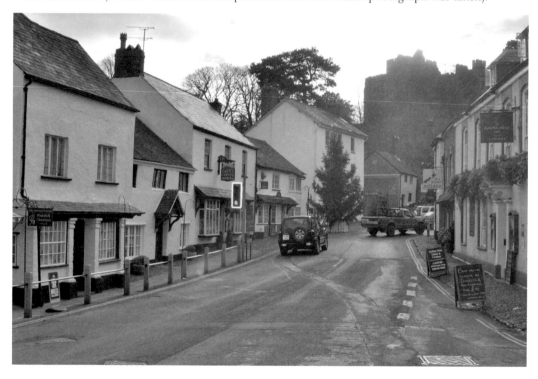

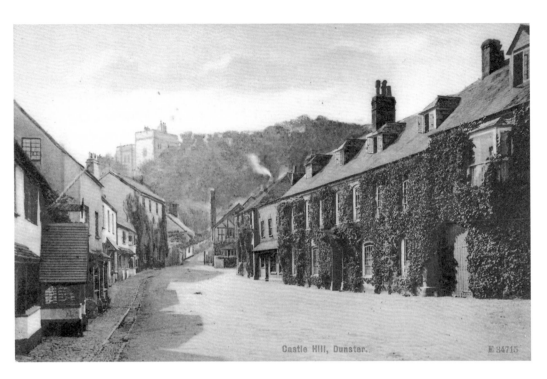

Castle Hill, Dunster.

E 84715

The High Street and Castle Hill, *c.* **1906**
Two images focusing on what is now the Dunster Castle Hotel, which is almost directly opposite the previously mentioned Castle Coffee House.

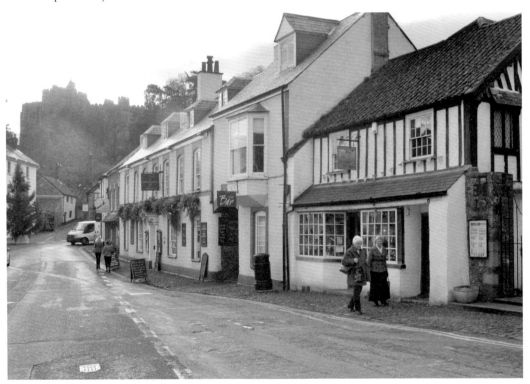

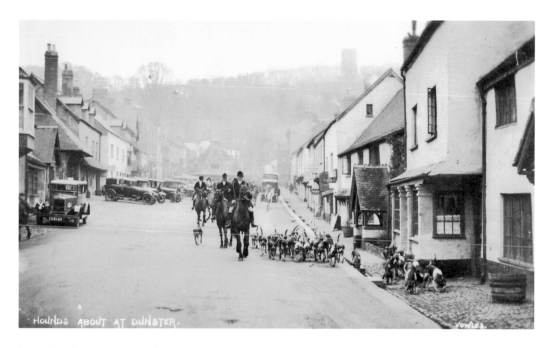

'Hounds About at Dunster', *c.* 1922
A real photographic postcard of hounds in the High Street, produced by local photographer Alfred Vowles, contrasted with a view of the same street as seen through the timbers of the medieval Yarn Market.

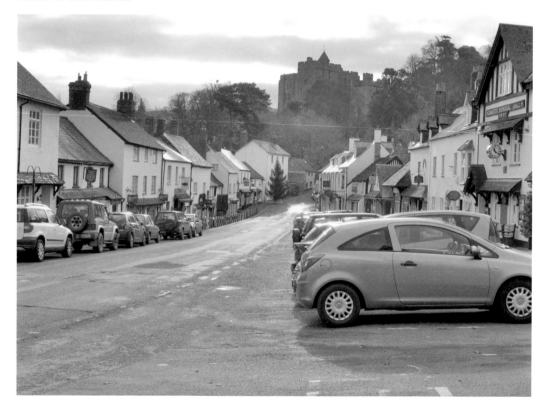

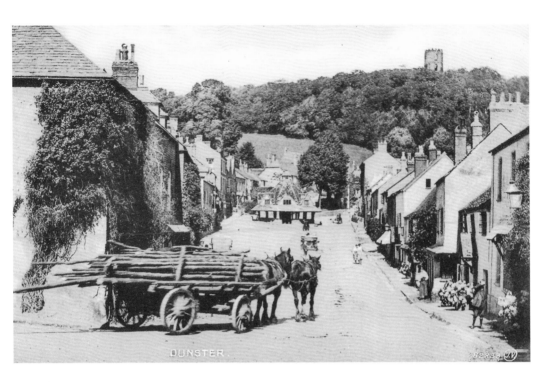

Dunster, *c.* 1900

Here we have a picture postcard of a horse-drawn wagon carrying timber from the West Street area of town up through the High Street. The photographer on both occasions positioned themselves on the incline up to the Castle.

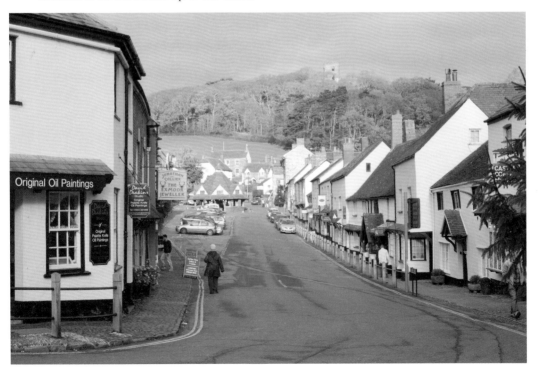

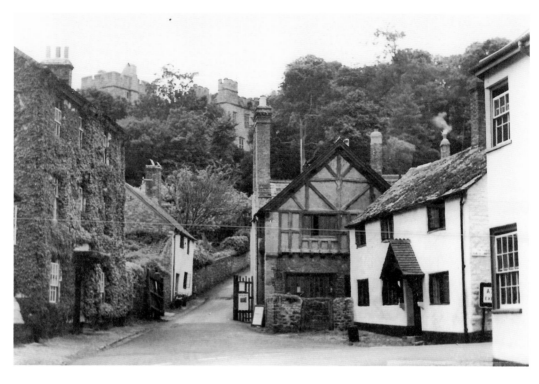

Castle Entrance, Dunster, *c.* 1953

Two photographs of the entrance to the Castle from the High Street. The tree on the left of the recent photograph is a temporary fixture, a Christmas tree awaiting decoration.

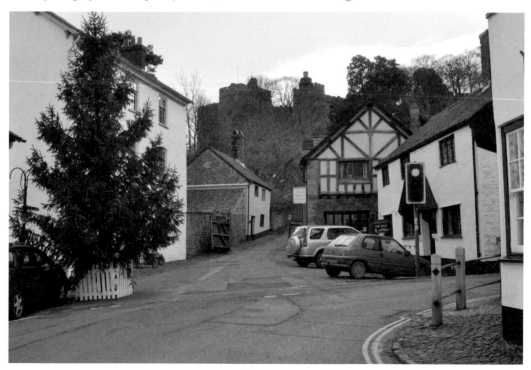

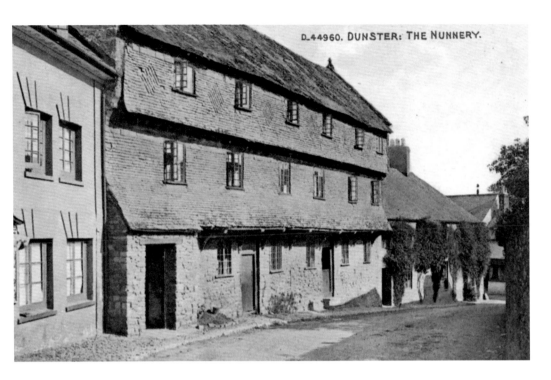

The Nunnery, Church Street, Dunster, *c.* 1909

In the fourteenth century, land in Dunster was granted to nearby Cleeve Abbey and the 'Nunnery' was built. Despite its name it was probably never actually inhabited by nuns and instead used as a guest house for the priory. It is a unique building of three storeys, with the upper ones decorated with tiles, and small windows high up in the east wall.

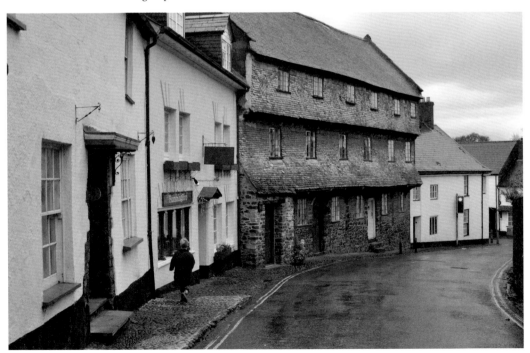

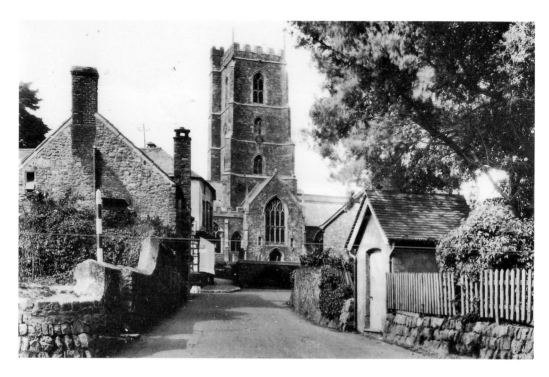

Dunster Church, *c.* 1955

The Priory Church of St George is predominantly fifteenth-century with evidence of twelfth- and thirteenth-century work. The tower was built by Jon Marys of Stogursey. He was paid 13*s* 4*d* for each foot in height and £1 for the pinnacles. The work was completed in three years. It has been designated as a Grade I listed building by English Heritage.

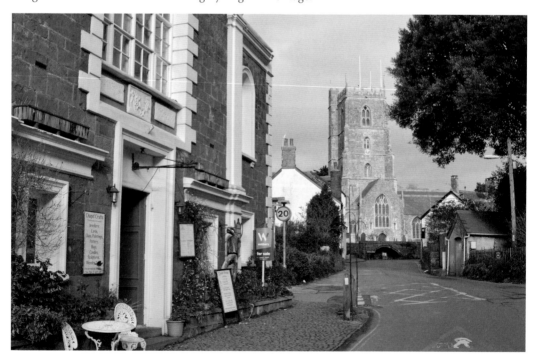

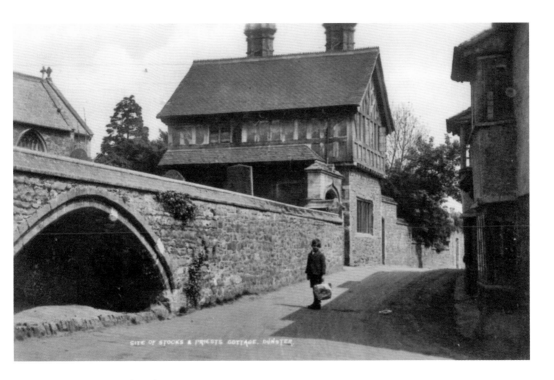

Priest's House, Church Street, *c.* 1923

Here we have photographs of the unusual arch in the churchyard wall and Priest's House. Although the publisher of the picture postcard describes the arch as the site of the stocks, some have claimed this to have been constructed as a water outlet. Either description appears perfectly plausible. The Priest's House dates from the late medieval period but was heavily restored in the late nineteenth century.

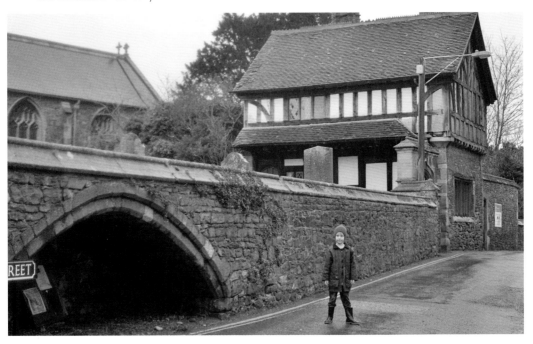

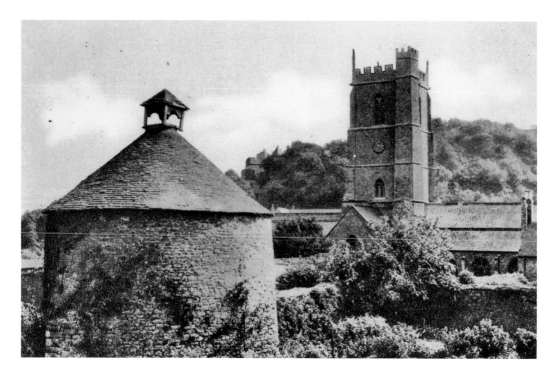

The Dovecote and Parish Church, Dunster, *c. 1930*
This structure intended to house pigeons or doves is believed to have been built in the late sixteenth century. Pigeons and doves were an important food source at this time in England and were kept for their meat, eggs, and dung! This dovecote is approximately 19 feet high, 19 feet in diameter, and has over 500 nest-holes.

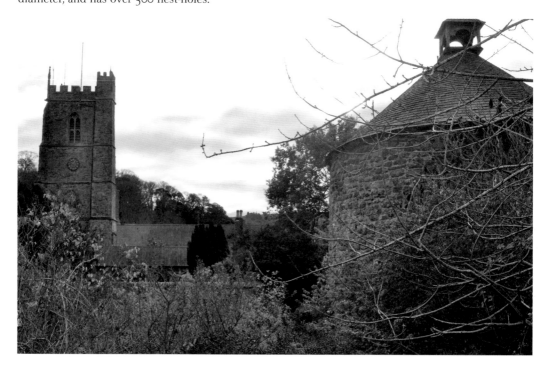

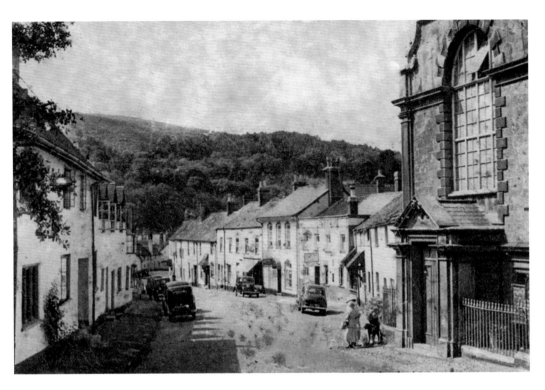

West Street, Dunster, c. 1960
The large building on the right here in West Street was a Methodist Chapel when the earlier photograph was taken. Today the building houses an excellent craft shop and a tea room.

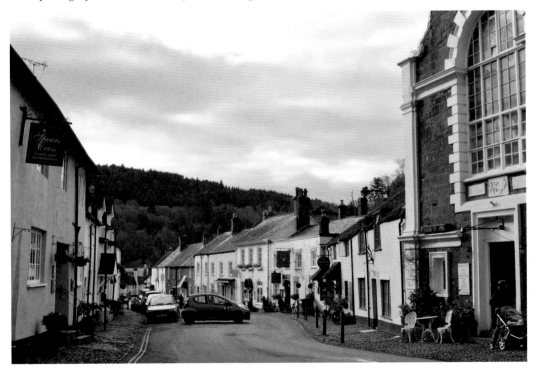

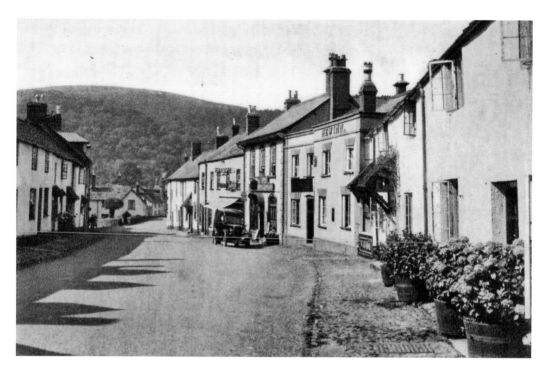

West Street, Dunster, c. 1910

Another look at West Street, this time from further away from the Priory Church. The pub shown in both photographs has been renamed from the New Inn to the Stag's Head but otherwise little of any real importance has changed. At the far end of West Street and out of shot is the watermill.

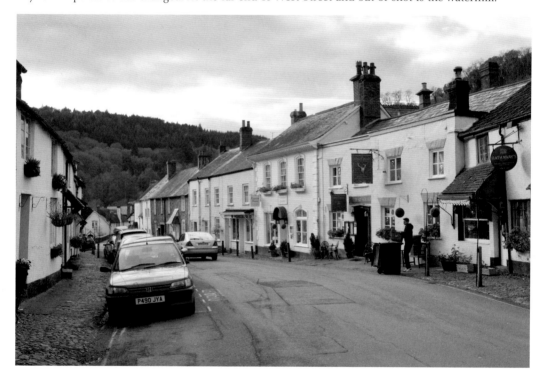

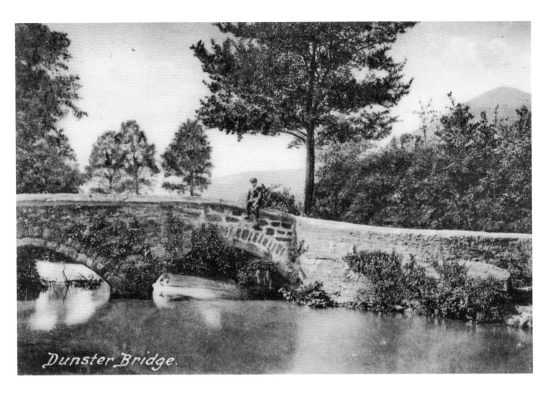

Dunster Bridge.

Packhorse Bridge, Dunster, *c.* 1907

Gallox Bridge is a narrow, medieval packhorse bridge over the River Avill. It was originally known as Gallows Bridge due to its proximity to the local medieval-period gallows and is unusual in being a long two-span bridge rather than the more usual single-span design. It is believed to date back to at least the fourteenth century and has been designated by English Heritage as a Grade I listed Scheduled Ancient Monument.

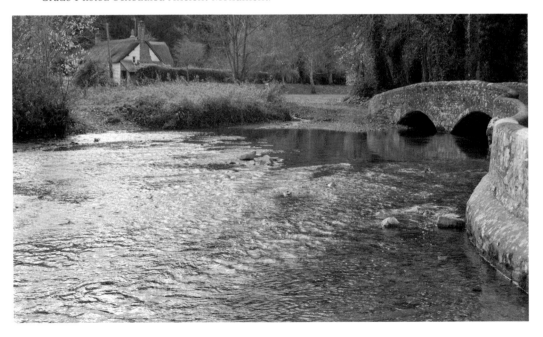

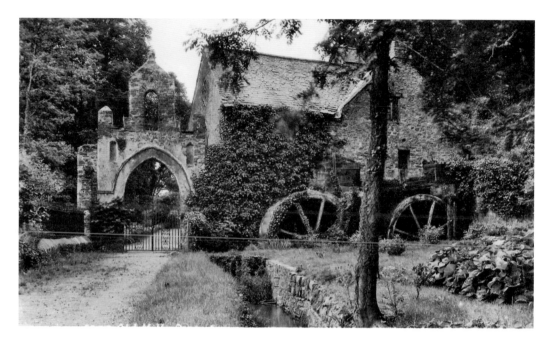

The Old Water Mill, Dunster, *c.* 1930

Dunster Watermill (also known as Castle Mill) is an eighteenth-century watermill, situated on the River Avill, in the grounds of Dunster Castle. The present mill, which was built around 1780, is built on the site of a mill mentioned in the Domesday Survey of 1086, and was restored to working order in 1979 by the National Trust. The watermill is fully operational and when open visitors are able to see flour being milled here and even buy the flour produced. Unfortunately, on the day of our visit in December the mill was closed, so our picture had to be taken from the other side of the gate.

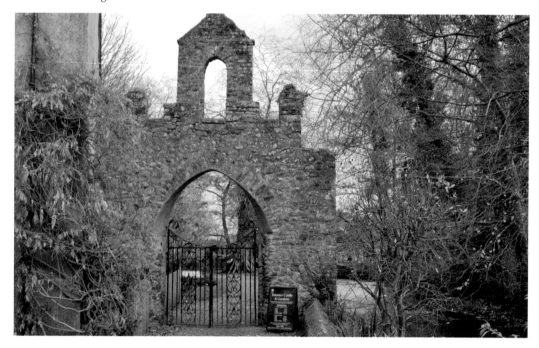

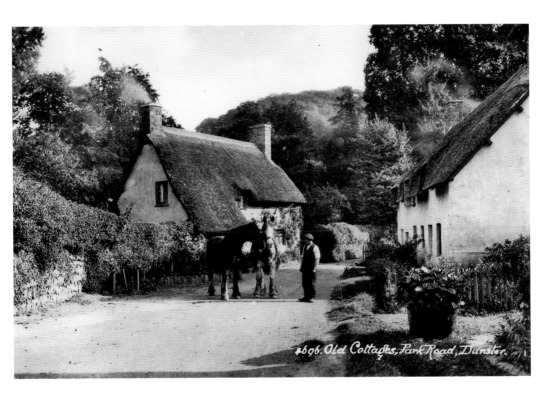

Old Cottages, Park Road, Dunster, *c.* 1935
Picturesque thatched cottages not far from the watermill.

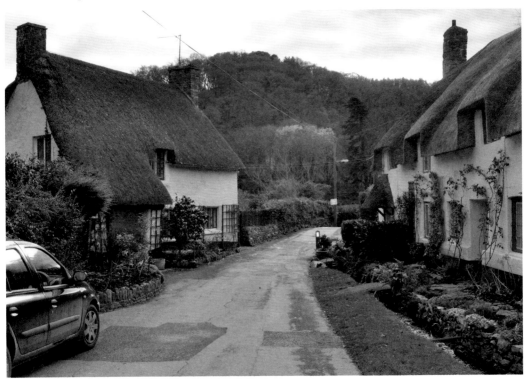

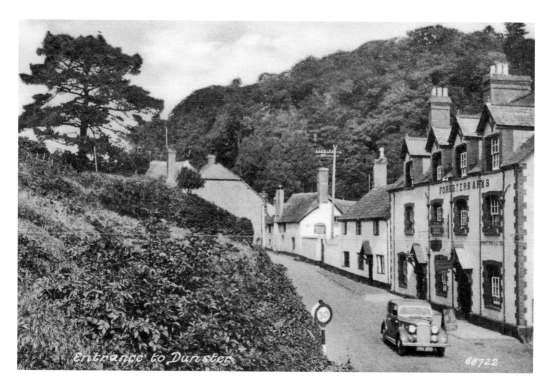

The Entrance to Dunster, c. 1955
Two views of the splendid Foresters Arms on West Street. If you are in the area and in need of good food and a friendly atmosphere this is one pub you should try. They also offer bed and breakfast.

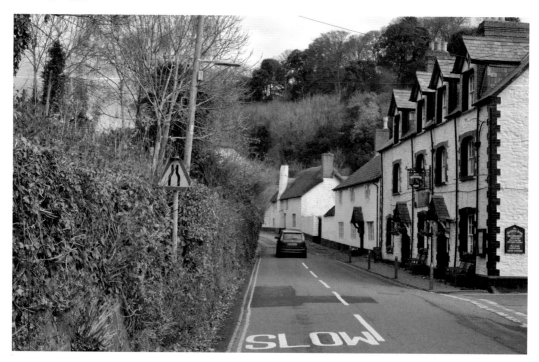

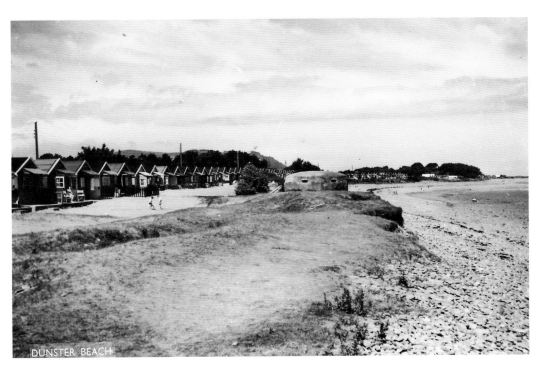

Dunster Beach, c. 1955

Dunster Beach, which includes the mouth of the River Avill, is located about half a mile from the village itself. The beach site has a number of privately owned chalets along with a small shop, a tennis court and a putting green. Many of the chalet owners rent them out to holidaymakers.

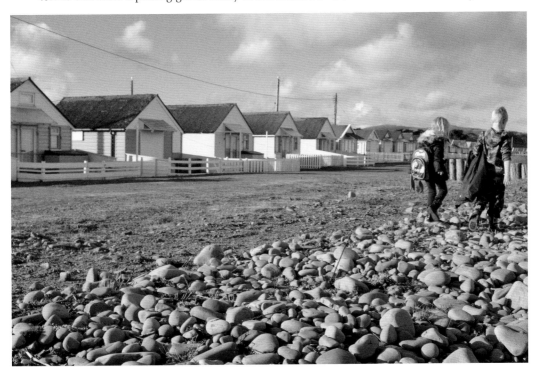

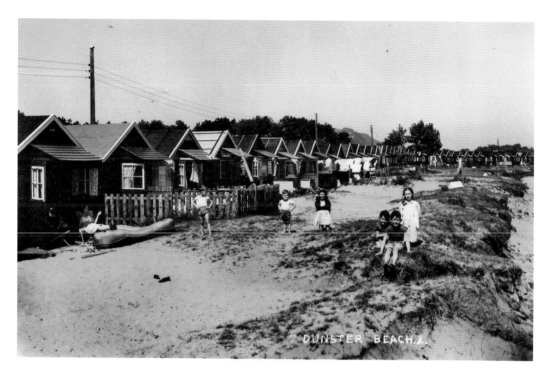

Chalets on Dunster Beach, c. 1955

A closer look at some of the chalets facing the beach in Dunster. Many of these were built in the 1920s when the area was first developed and when a new chalet facing the sea could be purchased for just £65. The chalets look much the same today but would, I'm sure, cost rather more to buy!

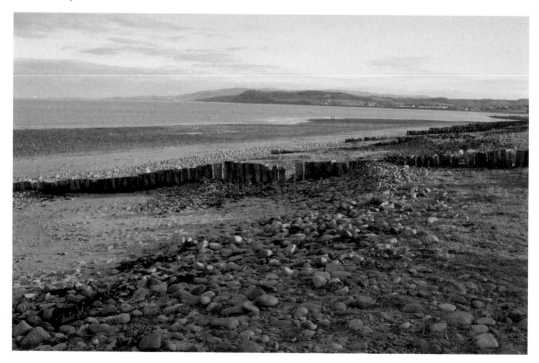

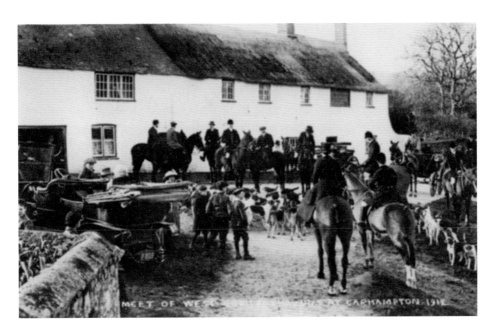

Meet of the West Somerset Foxhounds, Carhampton, *c.* 1912
A meeting of one of several local hunts outside of what is now the Butcher's Arms.
Carhampton is a small village approximately 1½ miles south-east of Dunster.

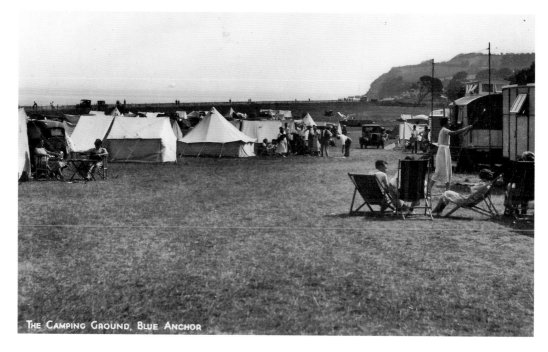

The Camping Ground, Blue Anchor

The Camping Ground, Blue Anchor, c. 1925
Around 1 mile along the coast from Dunster Beach and a similar distance north-east of Carhampton is the seaside resort of Blue Anchor. It is a quiet coastal location with a long, sandy beach popular with sea anglers and walkers. The bay is surrounded by alabaster rocks and cliffs, where interesting fossils can often be found. There are a large number of static caravans sited nearby.

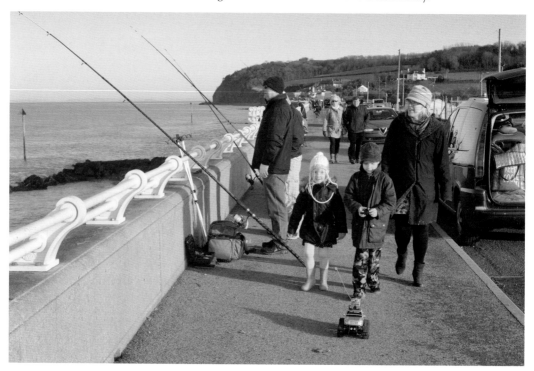

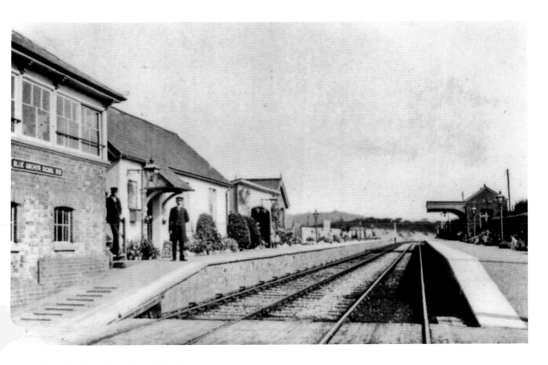

The Railway Station, Blue Anchor, c. 1905

Blue Anchor is just two stops away from the terminus of the West Somerset Railway in Minehead. Trains run between Minehead and Bishops Lydeard at weekends and on some other days from March to October, daily during the late spring and summer, and on certain days during the winter. The station itself was opened on 16 July 1874.

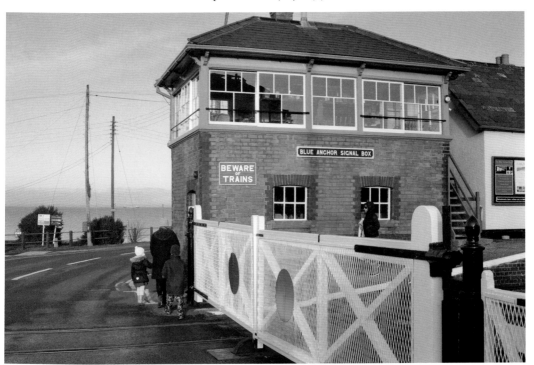

ALSO AVAILABLE FROM AMBERLEY PUBLISHING

Taunton Through Time
Simon Haines

This fascinating selection of photographs traces some of the many ways in which Taunton has changed and developed over the last century.

978 1 4456 1644 5
96 pages, full colour

Available from all good bookshops or order direct from our website www.amberleybooks.com